501 COLLECTIBLE HORSES

A Handbook and Price Guide

JAN LINDENBERGER

With Dana Cain

Schiffer Publishing Ltd

77 Lower Valley Road, Atglen, PA 19310

Acknowledgements

A very special thank you to Dana Cain from Atomic Antiques, for opening up her home and allowing me to photograph her wonderful and extensive collection. She gave me most of the information for this book.

Also thanks to:

Archie Tautfest, Sandbox Collectibles (Marx, Britains),
 Denver, Colorado
Lisa Janisch (Breyers), Denver, Colorado
Paris Reilley (Hartland, Breyers), Denver, Colorado
Briar Patch (Breyers), Denver, Colorado
Betty Hull (Carousel Horses), Littleton, Colorado
Karen Gerhardt (Hagen Renaker, North Lights), Boulder, Colorado
Atomic Antiques & Collectibles, Denver, Colorado
Colorado Antique Gallery, Littleton, Colorado
Maggie May's Sandbox, Denver, Colorado
Cowboy Collectibles, Aurora, Colorado
Becky O'Guin & Tony Keretiens, Lakewood,Colorado

Copyright © 1995 by Jan Lindenberger

Printed in China

ISBN: 0-88740-887-7

Book Design by Audrey L. Whiteside.

Published by Schiffer Publishing Ltd.
77 Lower Valley Road
Atglen, PA 19310
Please write for a free catalog.
This book may be purchased from the publisher.
Please include $2.95 for shipping.
Try your bookstore first.

We are interested in hearing from authors with book ideas on related subjects.

Library of Congress Cataloging-in-Publication Data

Lindenberger, Jan.
 501 collectible horses/Jan Lindenberger with Dana Cain.
 p. cm.
 ISBN 0-88740-887-7
 1. Horses--Collectibles--United States--Catalogs. I. Cain, Dana.
 II. Title
NK6077.3.L56 1995
704.9'432--dc20 95-35
 CI

Table of Contents

Introduction

September 23, 1966. My journey begins, when for my ninth birthday, my grandmother gives me a plastic horse. I name it Buttermilk, after Dale Evans' horse.

I don't know that it is a Breyer high gloss family stallion, and I certainly don't know what I'm getting into when I declare, "I'm going to collect horses now!"

Nearly thirty years and 500 horses later, I understand. Horse collecting has historically been dominated by young girls in grade school and junior high. They spend ages 5 through 9 pleading, "I want a pony" and eventually decide to settle for a small ceramic one. Many name each horse they acquire. It becomes more than a hobby. It becomes a heartfelt passion.

By the time they graduate from high school, however, many horse collectors have abandoned their old obsession for a new one - boys. Oh, well.

But some of us stick with it. Those who maintain collections into adulthood find that the hobby evolves, as we acquire more income and more aesthetic sensibilities. We start to buy horses because they look distinctive or artsy, because we don't have one in flame red or because we've never found one rolling on its back before.

The collection grows.

Beyond Breyer

For many, the heart of the horse collecting hobby is the Breyer Molding Company, which began issuing wonderful plastic horses in the 1950s, and continues to do so today. A lot of Breyer collectors participate in horse shows, winning ribbons in a small plastic version of a real live horse event. Some Breyer collectors even heat their horses to soften the plastic and re-shape existing models into a new figure altogether, adding paint and handmade tack to complete a sometimes-fabulous customized horse.

Breyer collecting has become so popular that some very rare Breyer models sell for thousands of dollars. However, Breyer collectors would like to remind everyone that not all Breyers should be expensive. Values are based on age, rarity and condition. Any rubs on the paint detract greatly from the value. Broken ears and other chips render these horses nearly value-less. High gloss models tend to sell for more than matte finishes, although there are exceptions. Some Breyer models have been in production for decades and are so common, even in glossy paint, that $15 might be a stretch.

But, beyond Breyer collecting, there are literally millions of fascinating horse figures to seek out, accumulate, and admire. And, while the non-Breyer side of horse collecting remains largely unorganized, it is an individual passion for millions of people.

It's not hard to find horses to buy, and many of them are priced very reasonably, even in antique shops. It's a hobby that allows collectors to spend as much or as little as they want, suited to any budget.

Toy Horses

Throughout the ages, children have played with toy horses. In this country, native Americans and pioneers alike carved wooden figures of horses for their children to play with.

When the toy industry began booming along with the baby boom in the 1950s and 60s, toy horses became popular. The Louis Marx company, famous for its tin and plastic toys, issued several horse-filled playsets in the 1950s and early 1960s, which have become collectible. Among the most notable was the rare "falling horse," available only in the giant-size version of the Civil War playset. The falling horse is currently valued at $35, its rider $50.

Also in the late 1950s and early 1960s, Breyer and Hartland Plastics both began issuing model horses by the thousands. Many Hartland horses were released alongside popular western stars of the times. Founded in the early 1950s, Hartland Plastics is still in business today, having survived harrowing floods and periods when other companies' names were stamped on its products. Today, though struggling financially, Hartland continues to issue wonderful horse figures, some with beautiful pearlescent finishes, others with highly collectible signatures on their stomachs.

During the 1980s, the era of Care Bears and Strawberry Shortcake, toys took on a new sugary sweetness. In 1982, Hasbro introduced My Little Pony, an enormously popular line which changed toy horses forever. Although realistic-looking Breyer horses continue to sell successfully, nearly every other horse in toy stores today is a "brush and comb" pony. Most are cute and pastel colored, with big eyes, long lashes and an outrageously long mane and tail made of synthetic, brushable hair.

Empire's Grand Champions line, currently available in toy stores, seems to offer a nice synthesis of the realistic Breyer appeal and the brushable mane and tail format. Grand Champions, billed as "the most beautiful horses in the world," are becoming very popular with younger collectors. Some interesting pieces in the line include a "talking stallion" that makes galloping and whinnying sounds when you press its saddle and limited edition horses available only to those willing to send in proof of purchase seals ("Blue Ribbon Points") through the mail.

The Horse as Art

The horse has endured as a symbol of strength and freedom throughout the ages. In fact, in this book, you'll find reproductions of horses created in Mesopotamia and in ancient China's Ching dynasty. More recently, companies like California's Hagen-Renaker and Britain-based North Lights have become known as leaders in the "fancy" horse collectors circuits. These horses are meant to be admired, not played with, and indeed, they are admired by collectors around the world.

Hagen-Renaker, founded in California in the 1950s, is most famous for producing tiny miniature ceramic animals typically glued to paper cards. Between the 1950s and 70s, however, the company produced a fabulous line of larger ceramic horses,which, today, have become quite collectible and hard to find. Some of the molds from these larger horses were leased to the Breyer Molding Company, and are still being produced in plastic.

North Light figurines have been produced in England for more than 20 years, although they are still relatively obscure in the United States. Made from a cold cast ceramic resin, they are highly detailed and very expressive of qualities horse collectors love. North Lights have begun appearing at Breyer horse shows throughout the country, and their fine craftsmanship has caused quite a stir among collectors. Although pricier than most Breyers, look for North Lights to become increasingly popular in the hobby.

Carousel Horses

Without a doubt, some of the finest examples of "the horse as art" are found in vintage carousel work. Carvers of the 1800s and early 1900s created carousel horses from blocks of wood, decorating them to catch the eye of a child passing a carnival merry-go-round. Today, collectors of carousel animals distinguish several types of carousel horses, many of which are quite valuable, commanding as much as $25,000-$75,000 each.

Flying horses, manufactured in the late 1800s, pre-date horses with "pole holes" and operated with centrifugal force, flying outward, hooked by chains to the ceiling of a merry-go-round. These horses often had tails made of real horse hair, and are frequently carved in a somewhat primitive or toll style.

The early 1900s represented what many consider the golden age of carousel horse carvings. The Philadelphia style, marked by realism and beautiful craftsmanship, today is one of the most highly collected styles of carousel horse. On a more "glitzy" note, the popular "Coney Island" style of carousel horse usually features many jewels and plenty of shine and shimmer. One popular Coney Island style carousel artist, M.C. Illions, always used gold leaf paint on his horses' manes.

Celebrity Horses

Some of the most beloved horses of all time rode the plains with the great film and TV cowboys: Trigger, Roy Rogers' beautiful palomino; Silver, the Lone Ranger's alabaster steed; and Champion, Gene Autry's faithful companion. They even had their own comic books!

Trigger, who is today stuffed and mounted in the Roy Rogers Museum, must be considered the single greatest horse collectible of the modern era, valued at about $2 million, but not for sale at any price.

Rest assured, however, that there is plenty of Trigger memorabilia that is for sale. In addition to the comic book, several figures and statuettes of the perfect palomino have been issued over the years. Also available are a lunch box, posters, lamps, plush toys and more! Trigger leads the herd when it comes to celebrity western horses.

Other TV horses, most notably Fury (1955-66) and Mister Ed (1961-66) were also popular, and today, Mister Ed has a huge fan following (the Ed Heads). The talking Mister Ed puppet easily brings $60-75.

Quick Draw McGraw, Hanna-Barbera's loveable animated sheriff, is probably more sought after by cartoon and Hanna-Barbera collectors than by horse collectors. Nonetheless, he and his deputy, Baba Looey are both equines!

Outside the realm of television, one family of the most beloved horses of all time came from Chincoteague Island, off of Virginia's eastern coast. Misty, Stormy, Sea Star and the other Chincoteague ponies captured America's heart when Margurite Henry wrote about them in her best-selling children's books. Based on true stories, Misty (first published in 1947) and Stormy (1963) have endured as children's classics. Today, Misty's descendants can be visited at the Chincoteague Pony Farm on neighboring Assateague Island, and if you're lucky, a trip to Chincoteague will include a wild pony sighting. Misty herself is stuffed (like Trigger) in the Misty Museum, a small trailer set up at the Chincoteague Pony Farm.

There are lots of great horses out there. This book shows just a sampling of the treasures that a diligent horse collector can acquire. Here's wishing you a long and fun-filled ride.

Dana Cain

Part 1: The Major Manufacturers

- Breyer

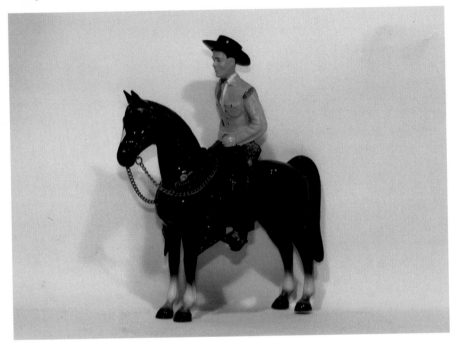

Breyer cowboy on western pony. 9.5". $200-250.

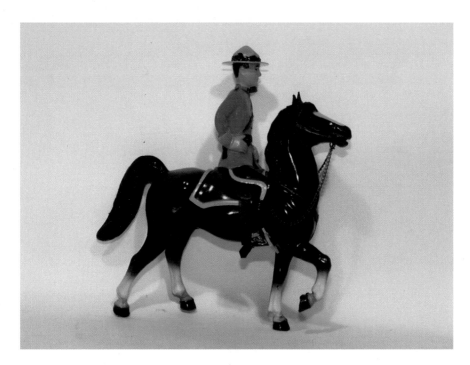

Breyer Canadian mounty. 1958. 9.5". $200-250.

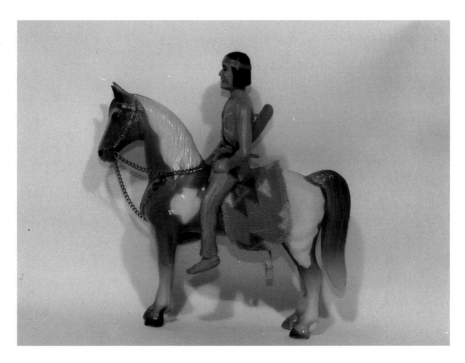

Breyer Indian brave. 1958. 9.5". $175-225.00.

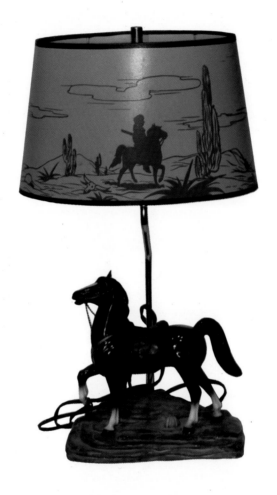

Breyer Davy Crockett lamp. 1958. With shade $200-250. Without Davy, $250-300.

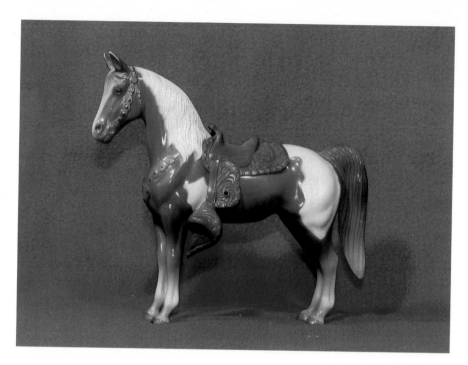

Breyer western brown and white pinto horse with snap on saddle. 9.5". #56. 1956-63. $45-60.

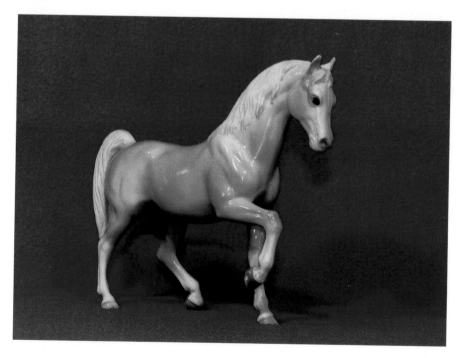

Breyer glossy family stallion-palomino. Tan. $35-45.

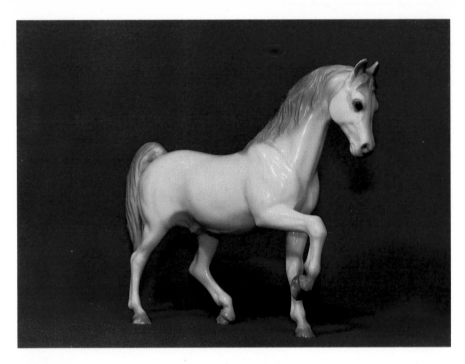

Breyer glossy family stallion-palomino. Gray. $35-45.

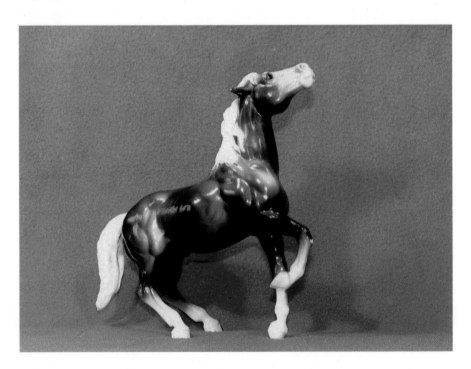

Glossy Breyer charcoal mustang. #88. 10". 1961-71. $85-100.

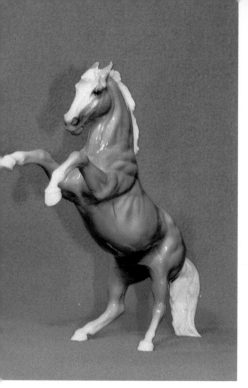

Breyer glossy fighting stallion, palomino. 11.25". #33. $45-55.

Breyer wood grain fighting stallion. 11.25". #931. 1961-74 . $125-150.

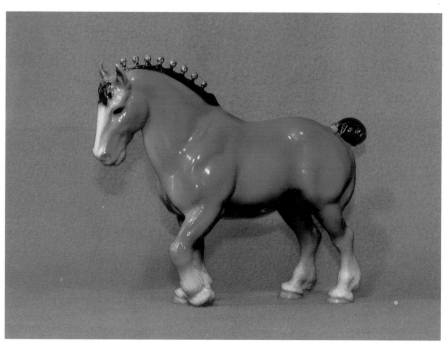

Breyer old glossy Clydesdale stallion. 8". #80. 1958-63. $45-55.

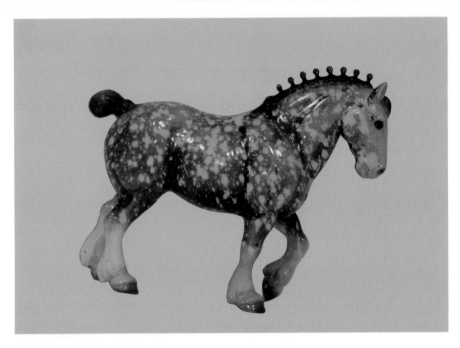

Breyer glossy dapple grey Clydesdale stallion. 9". $125-175.

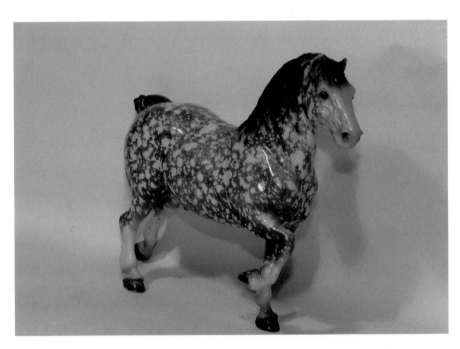

Breyer glossy dapple grey Belgian. 10". $150-200.

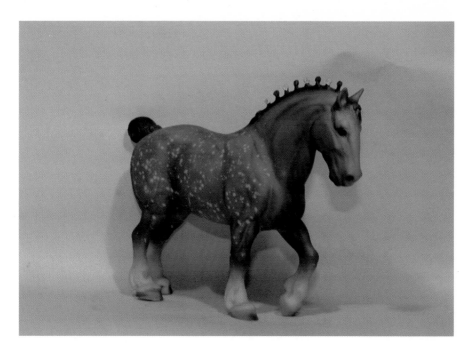

Breyer Clydesdale stallion, special issue. Mail order only. $80—100.

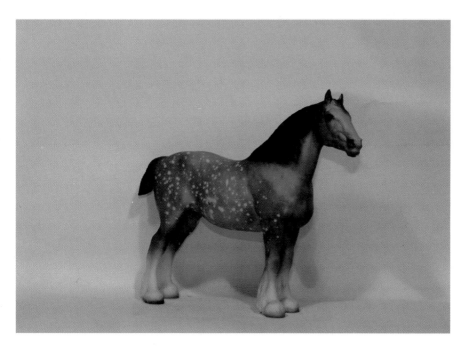

Breyer dapple Clydesdale mare. Special issue. Mail order only. 1980s. $80-100.

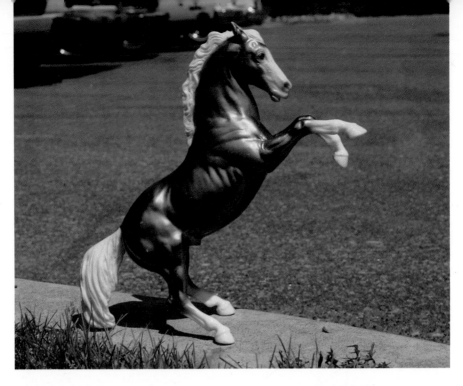

Decorator series-Breyer fighting stallion. Circa 1962. 11.5" tall. $400-450.

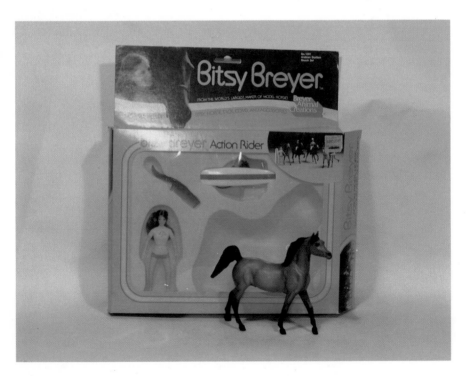

Breyer, "Bitsy Breyer." Little Bib Arabian stallion beach set. $35-50 set.

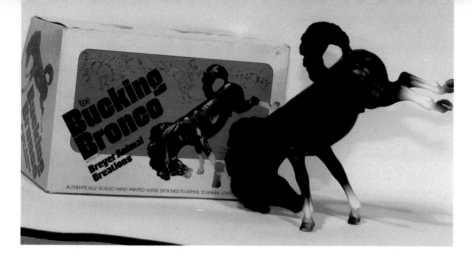

Breyer "Bucking Bronco" with box. 6.5". $90-110.

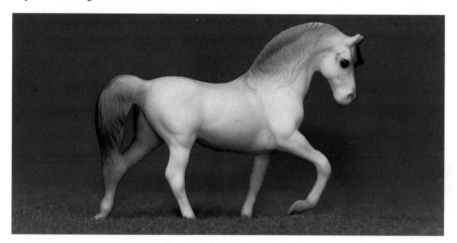

Breyer white Morgan stallion. 3 ". 1989. $10-15.

Breyer red roan laying down. #167. 4.25". 1969- 74. $55-65.

Breyer Hanovarian 8.5". #58. 1980-84.$40-50.

Breyer Walking gelding, appy quarter horse. 8.5". #97. 1971-80. $35-45.

Breyer Clydesdale foal. 7.75". #84. $15-22.

Breyer Stablemates, Seabiscuit. 3". 5024.
$15-20.

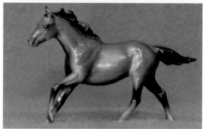

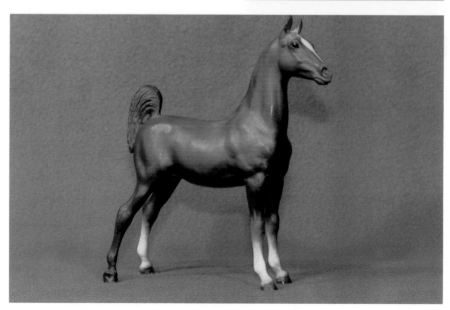

Breyer Old saddlebred yearling. 8.25". #62. 1973-81. $60-80.

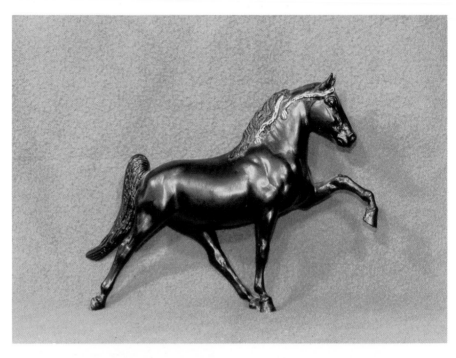

Breyer Midnight sun Tennessee walker. 8.75". #60. 1972-87. $20-30.

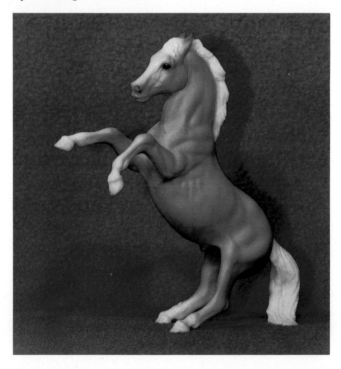

Breyer rearing stallion Palomino. 8.25". #183. 1965-85. $20-30.

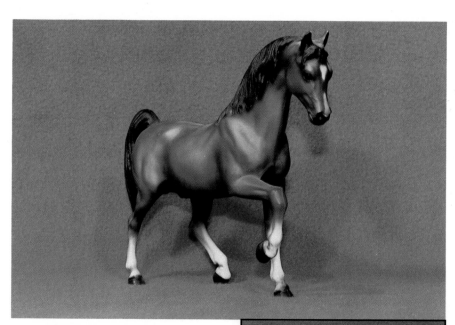

Breyer FAS Boy matte split blaze. 8.5".
#13. 1967-74. $20-30.

Breyer running foal. 7.25". #134. $20-30.

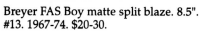

Breyer running brown mare. 9". #124.
$25-35.

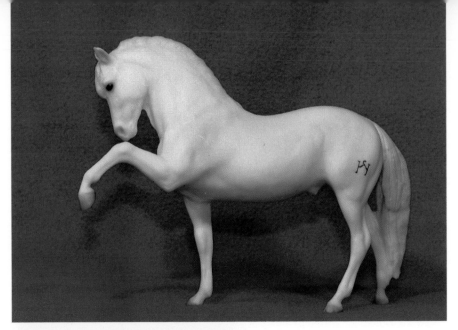

Breyer Legionan 3-famous A. 8.5". #68. 1989. $35-45.

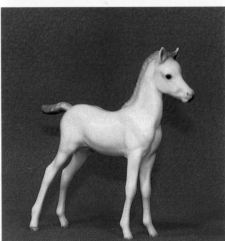

Breyer Arabian standing foal. $20-30.

Breyer Hobo on stand. 6.5". #626. 1976-83. $60-75.

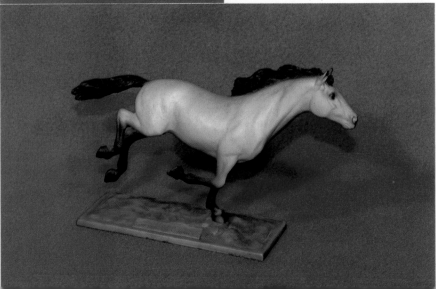

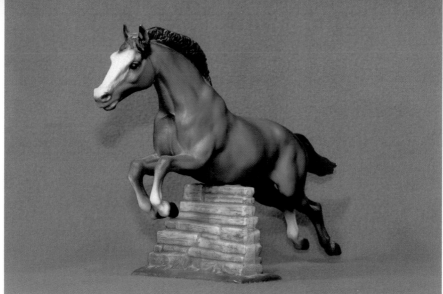

Breyer bay jumping horse. 9.5". #300.
1968-88. $30-45.

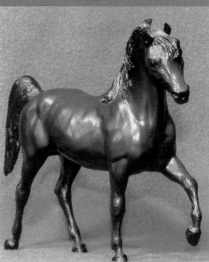

Breyer Hyskos-comm horse. 8.25". #832.
1991 only. $55-65.

Breyer Dixie. 8.5". #711. 1988 only. $40-50.

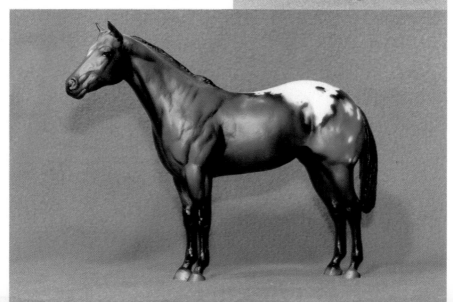

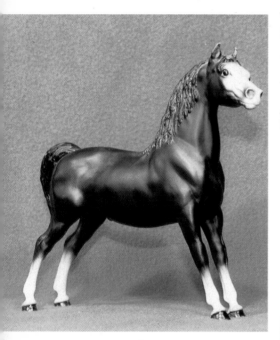

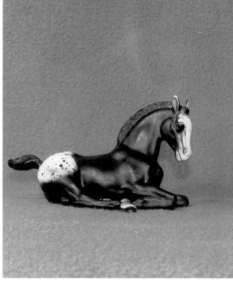

Breyer laying Appaloosa foal, 4". #165, 1969-1985. $25-35.

Breyer Gold Charm Secretariat. 7.25". 1989 only. $100-125.

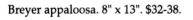

Breyer show stance Morgan. 9.25" #48. 1961-68. $25-35.

Breyer appaloosa. 8" x 13". $32-38.

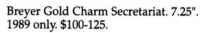

Breyer, special
"Mustang Lady",
event horse. 7".
1991. $250-300.

Breyer old sorrel 5
gaiter. 9.5". #52.
1961-63. $40-50.

Breyer buckskin Indian
pony. 7". $125-150.

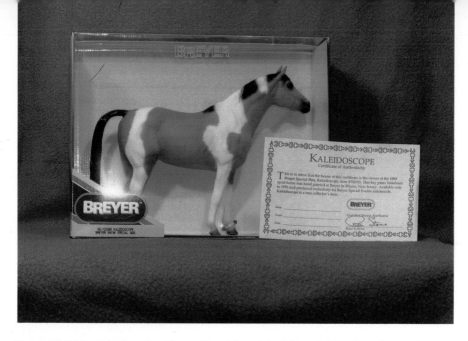

Breyer Kaleidoscope horse with certificate in original box. Sold only to horse show promoters. One per year. 1995. $30-40.

- Hartland Plastics

Hartland horse and rider set. 5". $50-75 set.

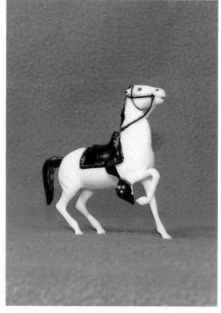

Hartland white plastic horse with black saddle. 4.5". $15-20.

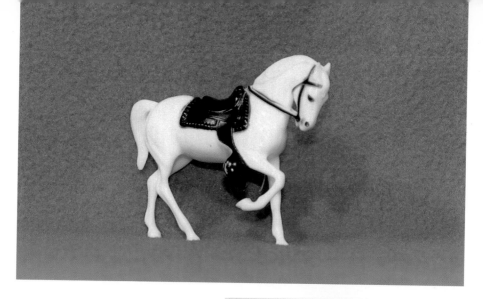

Hartland white plastic prancing horse
with saddle. 4.5". $10-15.

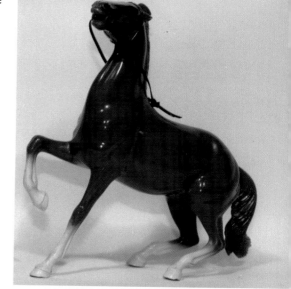

Hartland Rider series. Rearing plastic
horse. 8.5". $20-30.

Hartland Trigger. 6.5". $15-20.

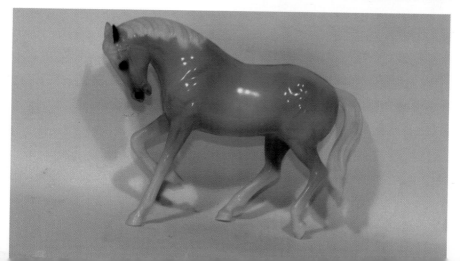

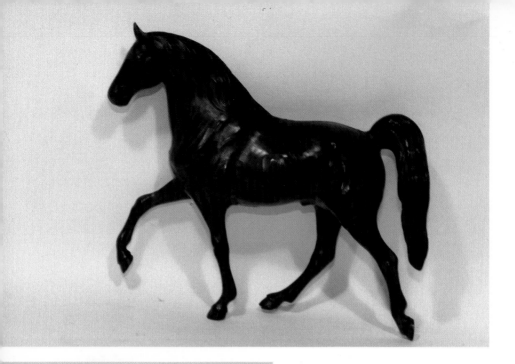

Hartland Onyx woodcut Tennessee walker. 8.25". $80-100.

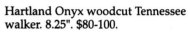

Hartland rearing mustang with walnut woodgrain. 9.5". $65-75.

Hartland woodgrain horse. 9". $30-35.

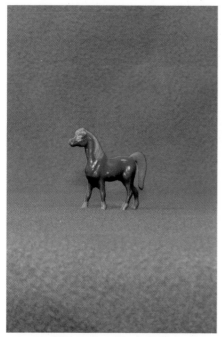

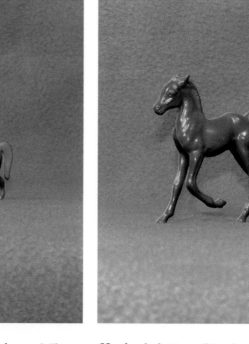

Tiny Mite plastic standing horse. 2.5".
$8-12.

Hartland plastic walking horse. 4.5". $8-12.

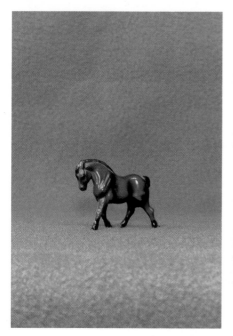

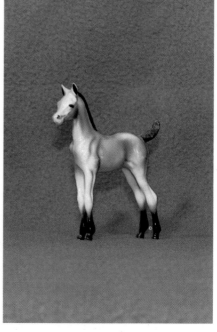

Tiny Mite plastic Clydesdale. 2.25". $6-10.

Hartland plastic gray horse. 5". $12-18.

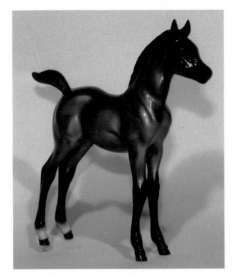

Weanling foal, metallic blue roan. 1st. off production line. Auctioned off at horse show. Signed.5". $35-45.

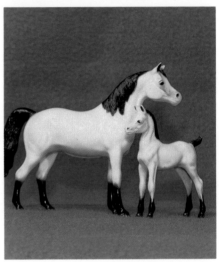

Hartland plastic Arabian mare and foal. Buckskin. 5". $15-20 pair.

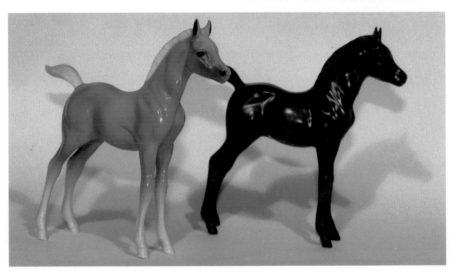

Weanling foals, bay and palomino. 6". $15-20 each.

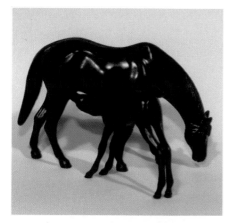

Black plastic grazing mare and nursing foal. Unpainted. 5.5". $15-20.

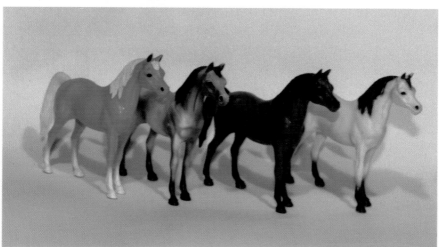

Arabian stallions. 5". 4 color variations. $3-5.

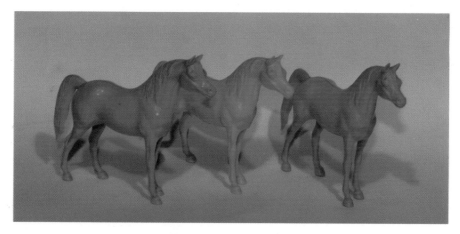

Arabian unpainted stallions. 5". $3-5 each.

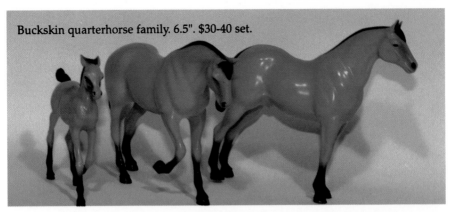

Buckskin quarterhorse family. 6.5". $30-40 set.

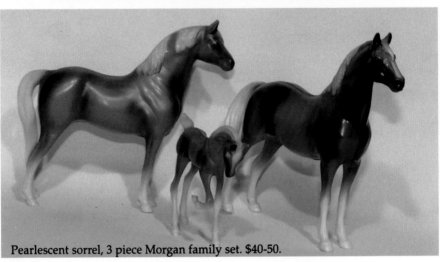

Pearlescent sorrel, 3 piece Morgan family set. $40-50.

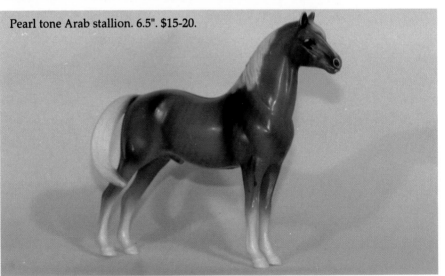

Pearl tone Arab stallion. 6.5". $15-20.

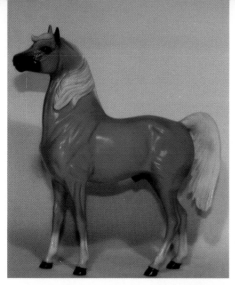

Hartland palomino Arabian, limited edition from 1990 horse show. Signed. $60-75.

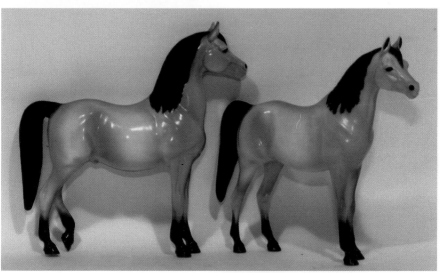

Hartland Arabian mare and stallion, hollow plastic. 7". $12-15 each.

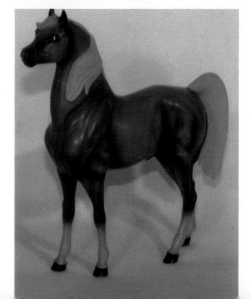

Hartland Arab stallion. 9". $30-40.

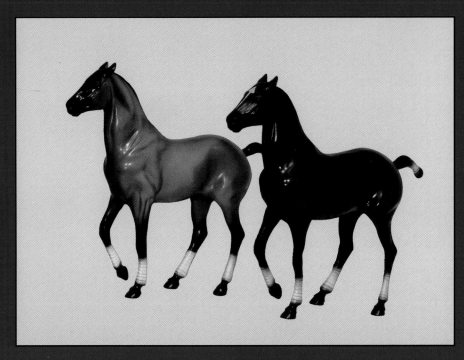

Hartland polo ponies, bay and grey variations. 8". $30-40 each.

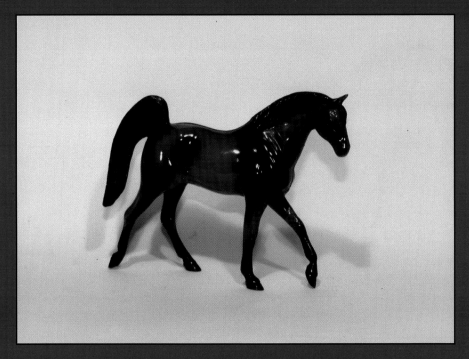

Hartland Tennessee walker. 6.25". $18-22.

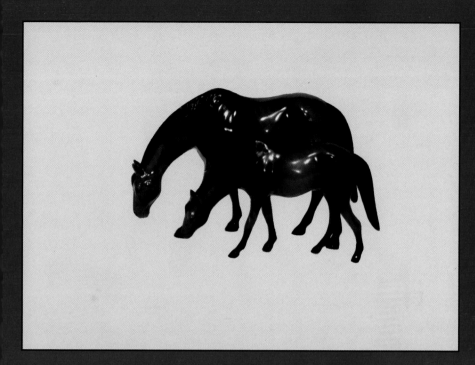

Hartland grazing mare. 4.5". $15-20. Foal, 3.75" $7-9.

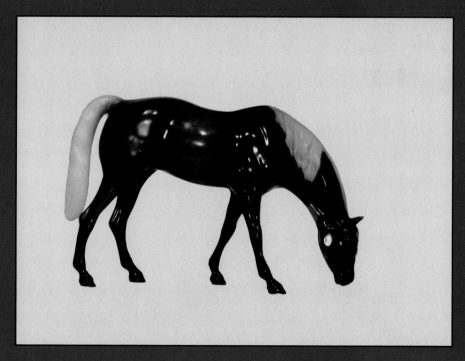

Hartland grazing mare, semi-rare, blue. 5.5". $90-125.

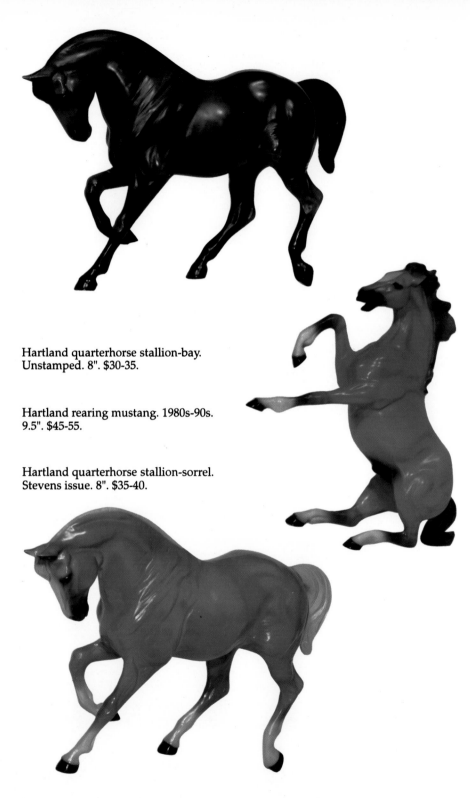

Hartland quarterhorse stallion-bay.
Unstamped. 8". $30-35.

Hartland rearing mustang. 1980s-90s.
9.5". $45-55.

Hartland quarterhorse stallion-sorrel.
Stevens issue. 8". $35-40.

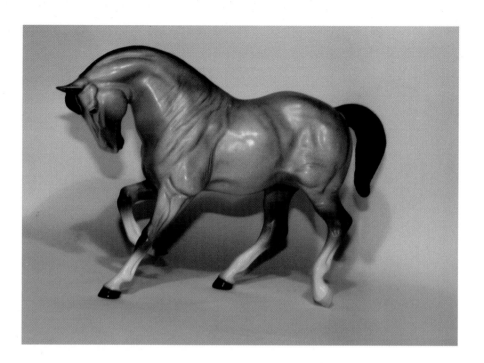

Hartland plastic quarterhorse stallion. Limited edition paint signed by Paula Groeler. Available at horse shows in 1989. 8". $60-75.

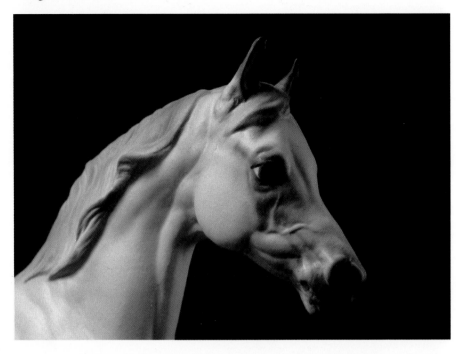

Hagen Renaker "Amir" Arabian stallion. 1957-68. $500-800.

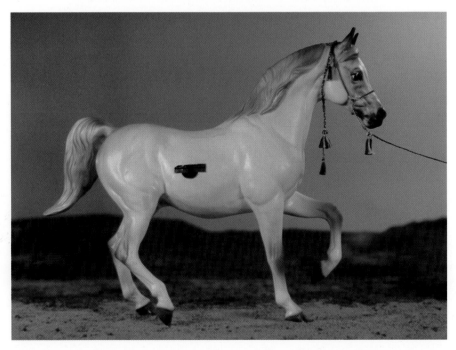

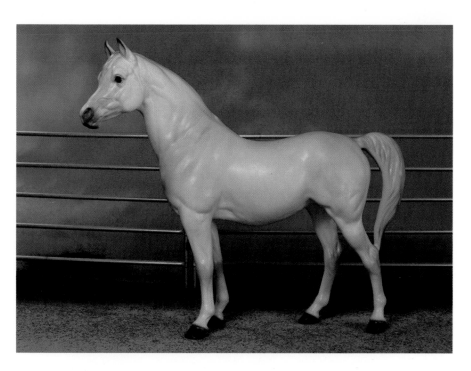

Hagen Renaker, "Zara" Arabian mare. 9". 1957-68. $500-800

Hagen Renaker Arabian mare. 1959-74. Matte finish. 6". $100-125.

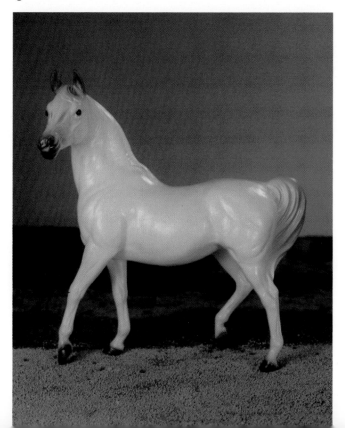

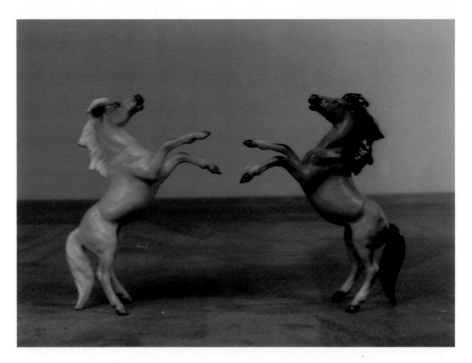

Hagen Renaker miniature "Rearing Horse". 1961-72. 4". $100-125 each.

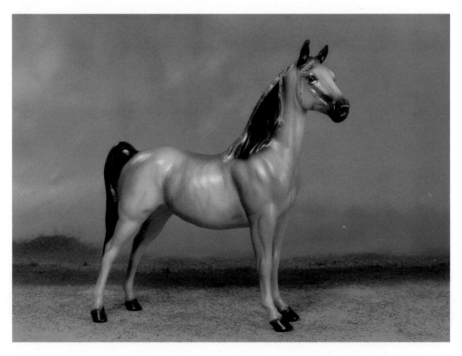

Hagen Renaker "Roan Lady" Tennessee walker horse, 1959-71. 7 3/4. $500-700

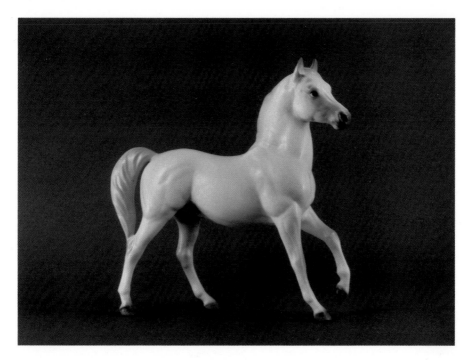

Hagen Renaker "Ferseyn" Arab stallion made from 1958 until 1970 in white, rose grey and ash grey with matte finish. 7.75". $500-700.

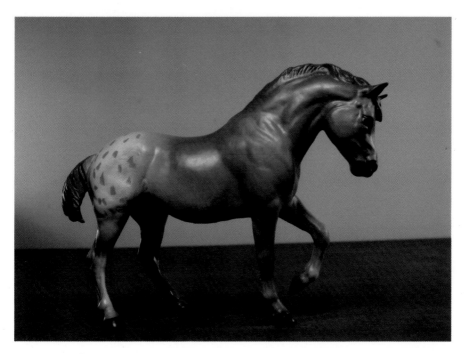

Hagen Renaker "Appaloosa" made from 1961-1968 only in this color. 4.75". $500-600.

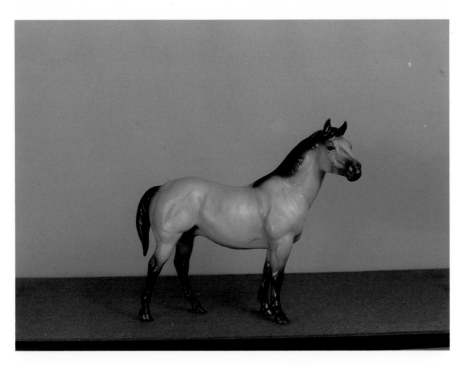

Hagen Renaker, "Two-bits" quarter horse stallion. 1959-1984. In buckskin and brown. Re-released in 1980-84 in glossy white and bay. 6". $100-125.

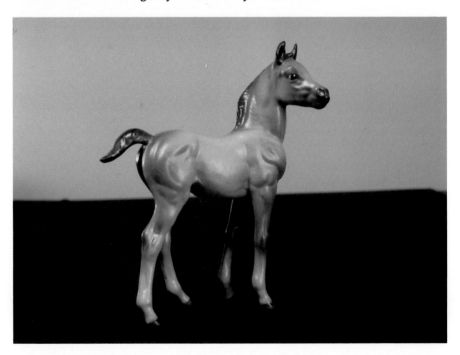

Hagen Renaker "Zillo" Arabian foal. 1959-74. 5". $100-125.

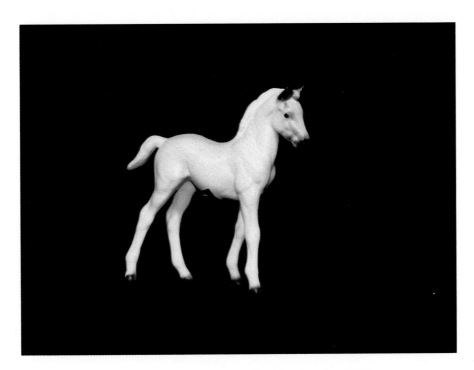

Ceramic palomino foal. "Roughneck" Hagen Renaker. 4.5". $100-125.

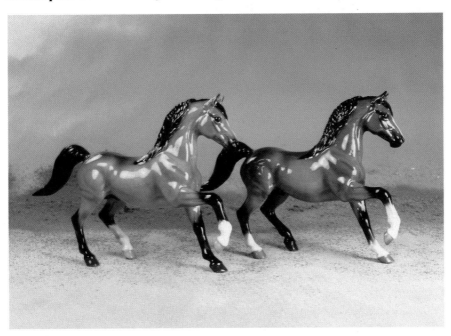

Hagen Renaker, plastic, special edition, "Encore" Arabian stallion. 5". Approximately 400 made in each of 4 color choices in 1994 only. White, bay, dapple grey, and chestnut. $150-200.

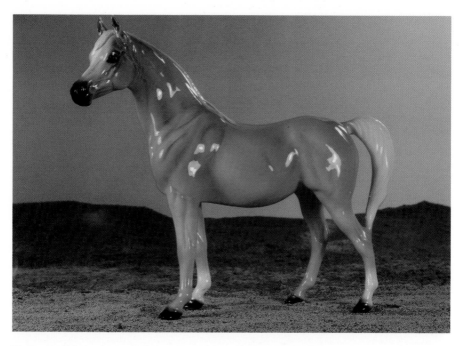

Hagen Renaker, gloss palomino. Re-release. (1980s). $250-300.

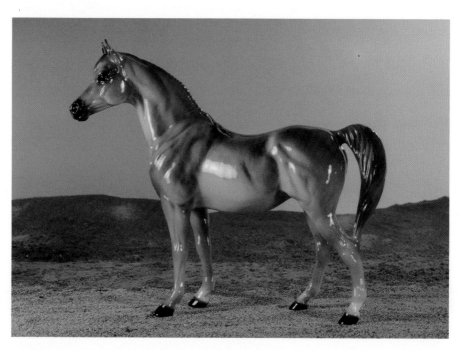

Hagen Renaker, "Zara" 1980-84 release. $250-300.

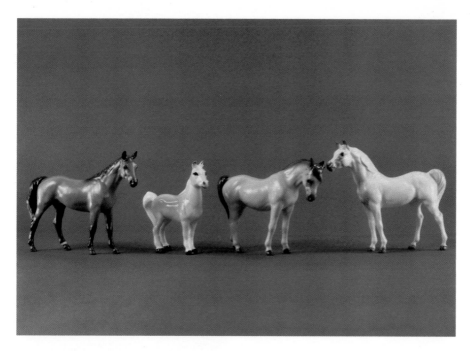

Hagen Renaker miniatures. Left to right: "Citation" race horse, 1961-71; early saddle horse, 1952-54, $40-50; Arabian mare, 1959-70, $80-100; Arabian stallion, 1959-72, $80-100.

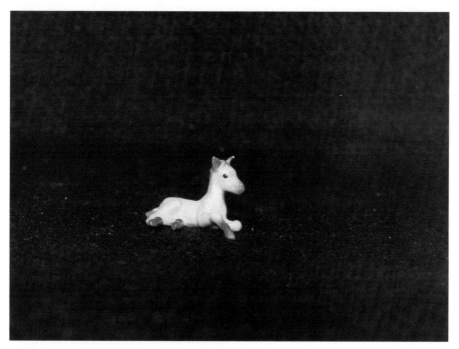

Ceramic lying foal. Hagen Renaker. 5". $50-60.

- Marx

Fat body gray Marx horse. 2.75". $5-7.

Cream color rearing Marx plastic
stallion. 3". $5-7.

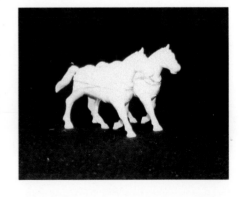

Brown and white plastic Marx
galloping horses. 2". $4-6.

Cream color plastic Marx wagon horses.
2.25". $3-5

Galloping Marx plastic horse. 2.5". $3-4.

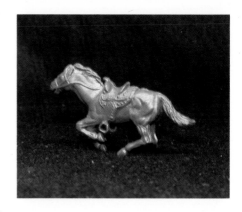

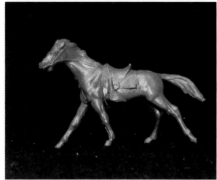

Plastic Marx running horse. 4.5" x 2.75". $3-4.

Plastic Marx dead horse. 4". $15-20.

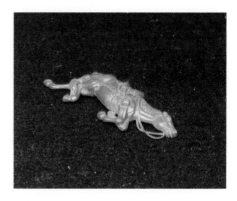

Marx toy plastic falling horse civil war figure with rider. 4" x 2.5". 1950s-60s. $35-50 horse and $35-50 rider.

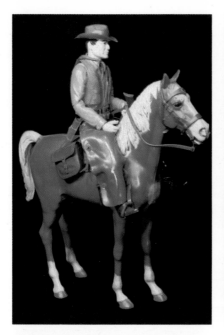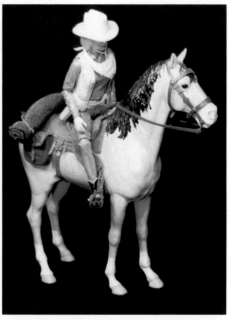

Best of the West 1960s, Thunderbolt and Johnny West. 12" x 15". $55-75 with horse and rider.

Best of the West 1960s, Thunderbolt Buckskin, Jane West doll and horse. 12" x 15". $55-75 with horse and rider.

Best of the West grey plastic horse from Germany. 12" x 15". $75-95.

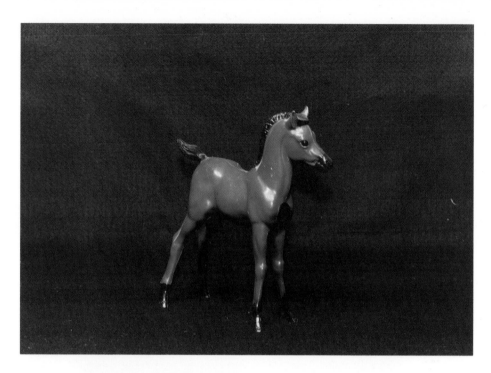

Best of the West plastic colt. 9" x 10". $15-20.

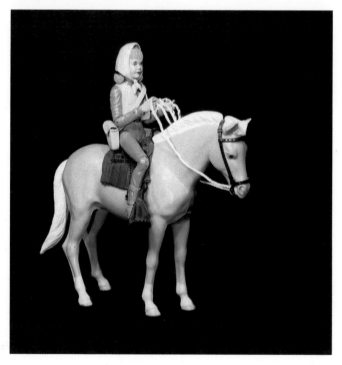

Best of the West Pancho, plastic horse and rider. 9.5" x 12". $20-30.

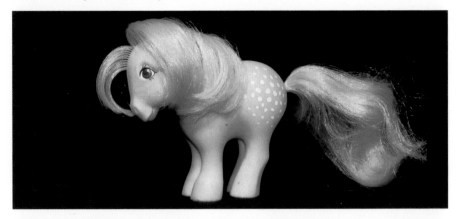

Hasbro's My Little Pony, pink with spots on rear. 1982. $3-4.

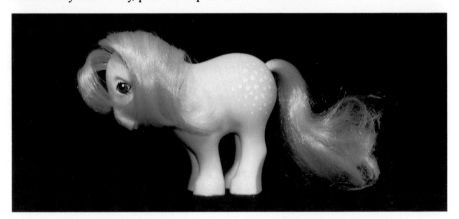

Hasbro's My Little Pony, pink with light spots on rear. 1982. $3-4.

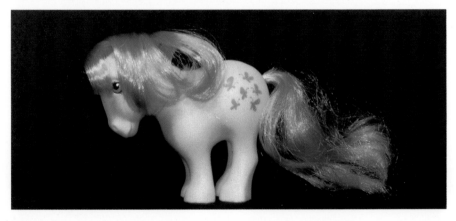

Hasbro's My Little Pony, orange with butterflies on rear. 1982. $4-5.

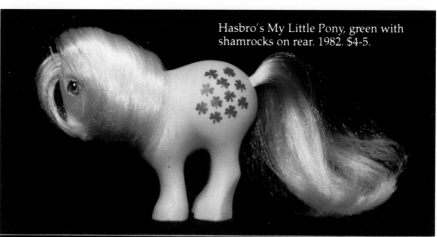

Hasbro's My Little Pony, green with shamrocks on rear. 1982. $4-5.

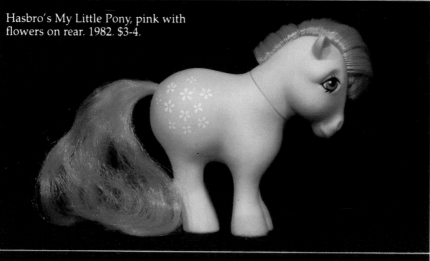

Hasbro's My Little Pony, pink with flowers on rear. 1982. $3-4.

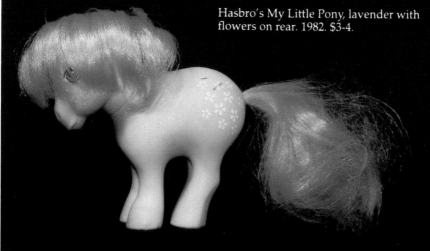

Hasbro's My Little Pony, lavender with flowers on rear. 1982. $3-4.

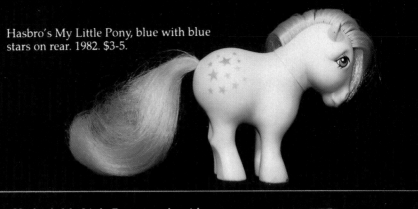

Hasbro's My Little Pony, blue with blue stars on rear. 1982. $3-5.

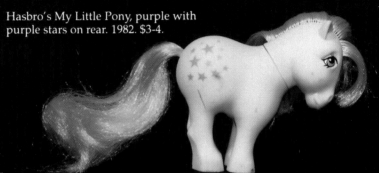

Hasbro's My Little Pony, purple with purple stars on rear. 1982. $3-4.

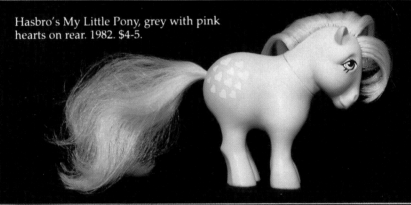

Hasbro's My Little Pony, grey with pink hearts on rear. 1982. $4-5.

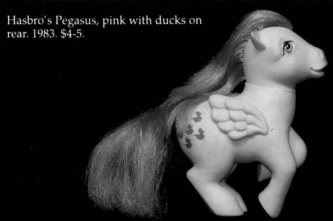

Hasbro's Pegasus, pink with ducks on rear. 1983. $4-5.

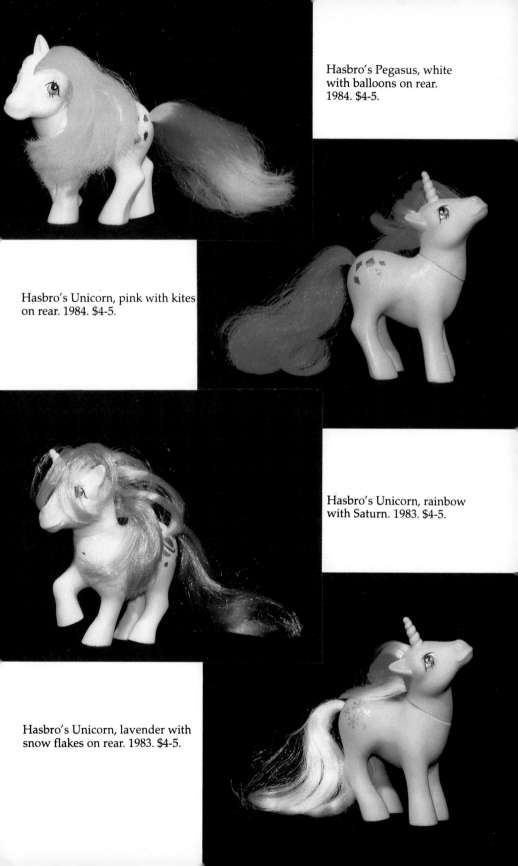

Hasbro's Pegasus, white with balloons on rear. 1984. $4-5.

Hasbro's Unicorn, pink with kites on rear. 1984. $4-5.

Hasbro's Unicorn, rainbow with Saturn. 1983. $4-5.

Hasbro's Unicorn, lavender with snow flakes on rear. 1983. $4-5.

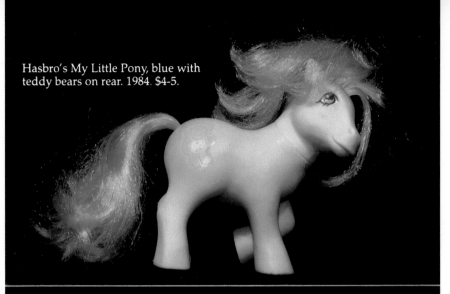

Hasbro's My Little Pony, blue with teddy bears on rear. 1984. $4-5.

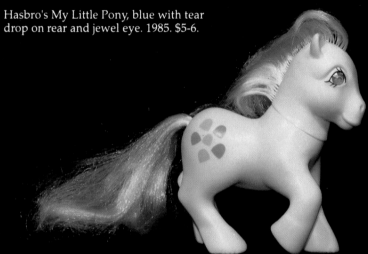

Hasbro's My Little Pony, blue with tear drop on rear and jewel eye. 1985. $5-6.

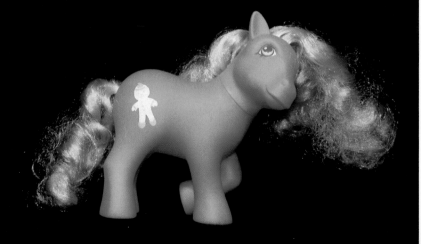

Hasbro's My Little Pony, pink with gingerbread on rear. 1984. $4-5.

Hasbro's My Little Pony, strawberry scented with strawberries on rear. 1987. $5-7.

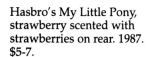

Unicorn mini Unicorn with bows on rear. 1986. $4-5.

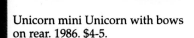

Pink mini My Little Pony with teddy bears on rear. 1989. $4-5.

Hasbro's My Little Pony, clock on rear and jeweled eyes. $5-6.

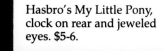

Hasbro Unicorn with sodas on rear. 1985. $5-6.

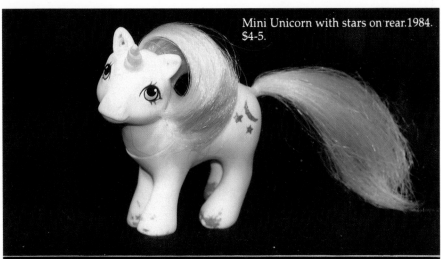

Mini Unicorn with stars on rear. 1984. $4-5.

White Wedding pony 1989. $7-8.

Mini Unicorn with bunnies on rear. 1987. $4-5.

Pink sea pony, no mark. $6-7.

Hasbro mini flutter wing pony. 1988. $10-13.

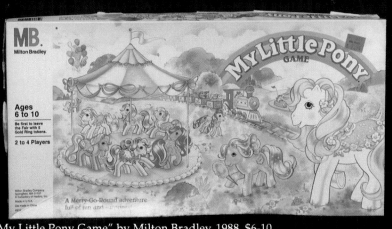

"My Little Pony Game" by Milton Bradley. 1988. $6-10.

North Light "Hunter". Special order, chestnut pinto. 7". $125-150.

North Light "Irish Draught" mold dark dapple grey. 10" tall. $200-300.

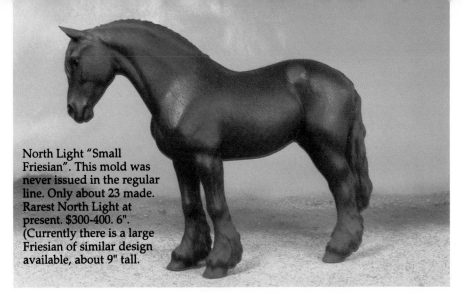

North Light "Small Friesian". This mold was never issued in the regular line. Only about 23 made. Rarest North Light at present. $300-400. 6". (Currently there is a large Friesian of similar design available, about 9" tall.

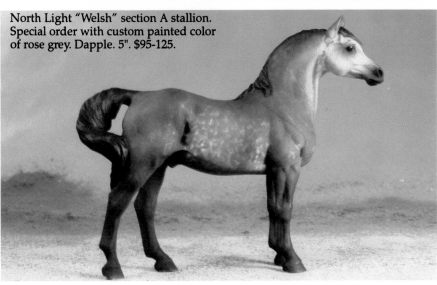

North Light "Welsh" section A stallion. Special order with custom painted color of rose grey. Dapple. 5". $95-125.

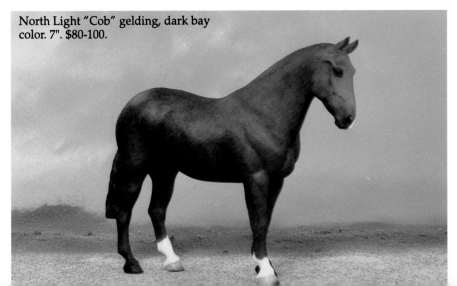

North Light "Cob" gelding, dark bay color. 7". $80-100.

Part 2: The Image Of The Horse

- Ceramics

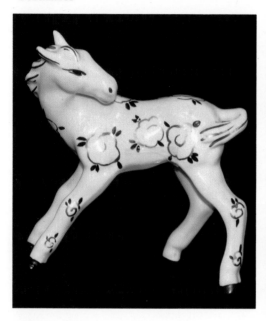

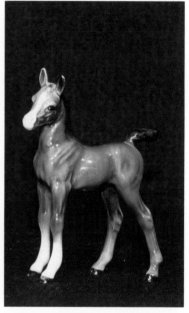

Gridleyware pony with gold trim on ceramic body from Sebring, Ohio. 6". $25-30.

Ceramic standing foal. White blaze, Beswick, England. 4.5". $18-25.

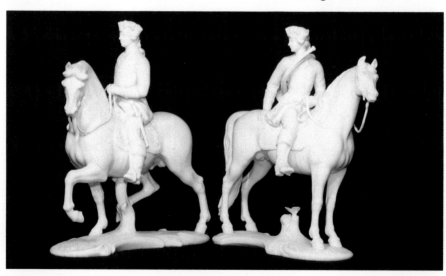

Nymphenburg, pair of white porcelain horse figurines with riders. 8.5". $230-250.

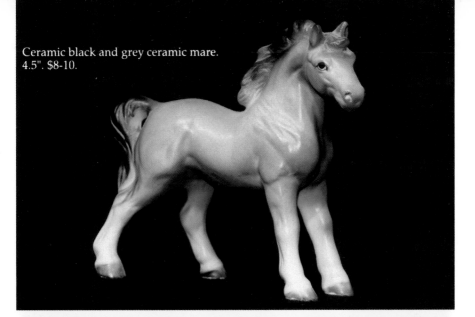

Ceramic black and grey ceramic mare. 4.5". $8-10.

Ceramic walking horse with black mane. 5.5". $14-18.

Ceramic black standing horse. Japan. 4". $9-11.

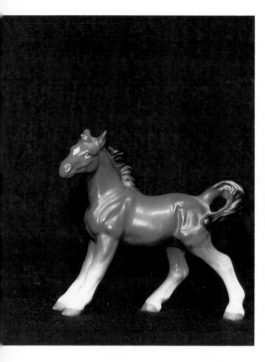

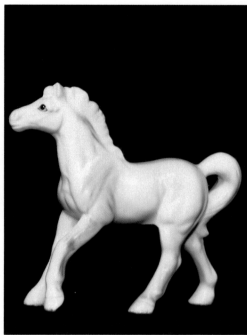

Ceramic brown mare with white feet. Japan. 3.75". $10-12.

Ceramic white mare. 3.75". $8-10.

Ceramic brown mare with bridle. Japan. 3.75". $10-12.

Ceramic foal, marked "Japan" with clover. 4.25". $10-12.

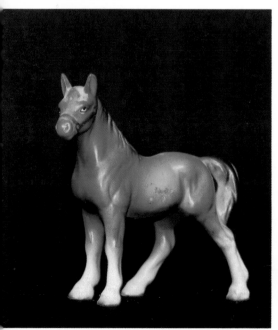

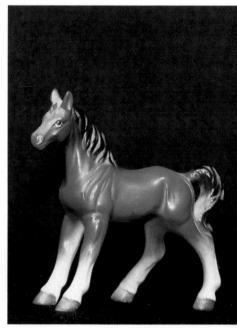

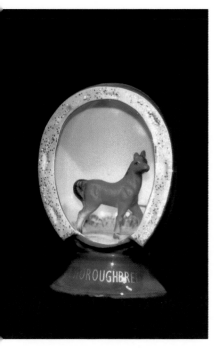

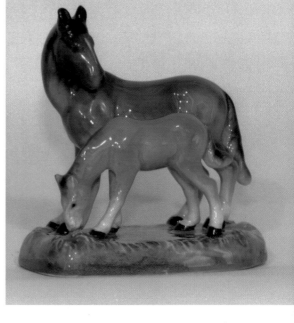

Thoroughbred in egg with horseshoe around edge. 2.75". $26-32.

Ceramic mare and foal on grass. Made in Japan. 5". $20-25.

Ceramic standing foal. Gosep-Originals. Korea. 5". $15-22.

Ceramic pinto foal. Le Faon-Japan. 4.5". $18-22.

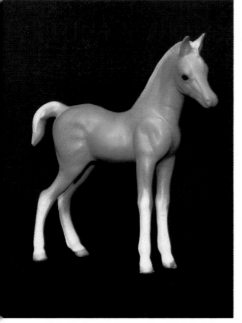

Woodcarved-look walking horse. 3.75".
$8-12.

Ceramic white figural mare and foal.
2.25". $4-6.

Ceramic tan mare with foal. 2.75". $3-5.

Ceramic horse with white fur mane and beaded blanket. Japan with blue sticker.
3.75". $16-20.

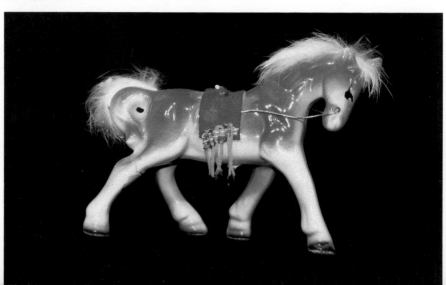

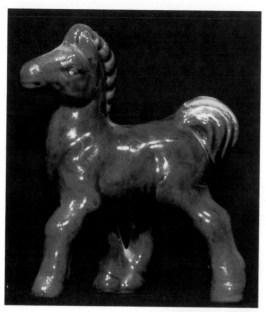

Ceramic brown with gold mane and tail. Japan. 4". $6-8.

Ceramic white horse. Made in Japan. 4.5". $9-12.

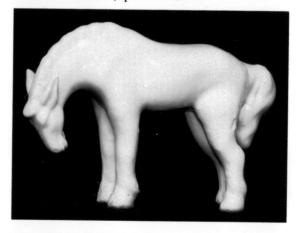

Ceramic brown figural Clydesdale. 4". $18-22.

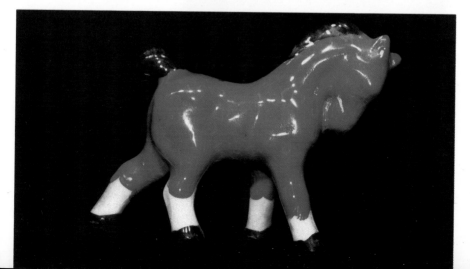

Ceramic standing horse with red sticker, Japan. 3". $12-16.

Ceramic black yearling. Deco style, Pigeon Forge. 2". $16-22.

Ceramic tan figural foal. 2.5". $15-18.

Ceramic blue draft horse figure. 2.75". $15-18.

Ceramic pony with head bent down. Japan. 2.75". $12-15.

Ceramic white Bug horse. Japan. 1.75" $6-8.

Ceramic brown Bug horse. Japan. 1.75". $6-8.

Ceramic grey horse standing on grass by Wade. England. 1.5". $10-15.

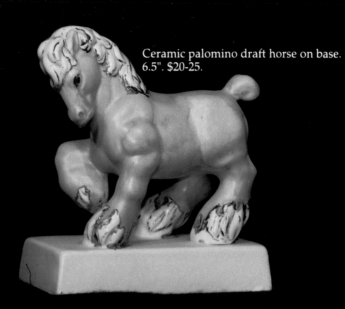

Ceramic palomino draft horse on base. 6.5". $20-25.

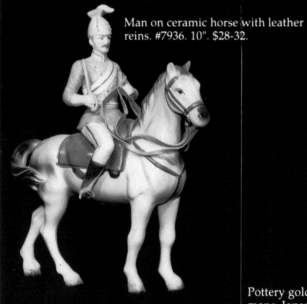

Man on ceramic horse with leather reins. #7936. 10". $28-32.

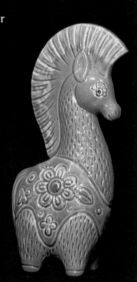

Pottery gold glazed pony with large mane. Japan. 9". $8-10.

China figural coach and horses. 3.5". $30-35.

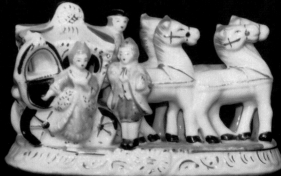

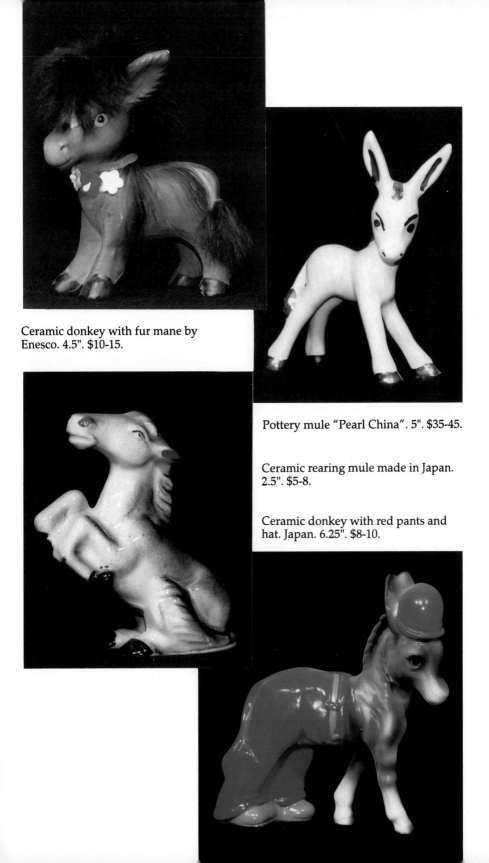

Ceramic donkey with fur mane by
Enesco. 4.5". $10-15.

Pottery mule "Pearl China". 5". $35-45.

Ceramic rearing mule made in Japan.
2.5". $5-8.

Ceramic donkey with red pants and
hat. Japan. 6.25". $8-10.

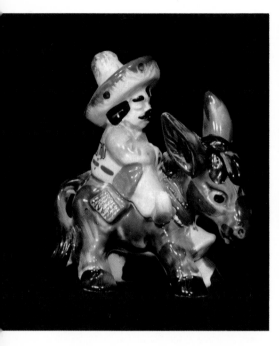

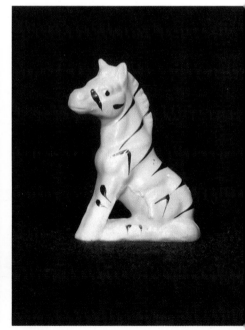

Pottery souvenir from Pikes Peak, CO. Donkey with rider. Made in Japan. 5". $13-18.

Ceramic pegasus on base. 5.5". Deco style. $20-25.

Pottery mule with rhinestone eye. 3". $7-10.

Ceramic blue zebra. 2.5". $6-10.

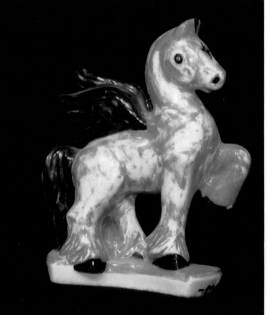

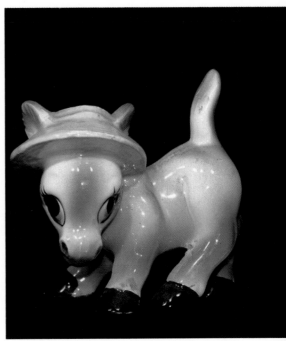

Porcelain resting unicorn. 1". $5-8.

Ceramic donkey with pink hat. 3". $3-5.

Grey donkey with golden crown mark. Victoria-Japan. 5". $18-22.

Porcelain pegasus rearing. 1978. Japan. 7.75". $35-45.

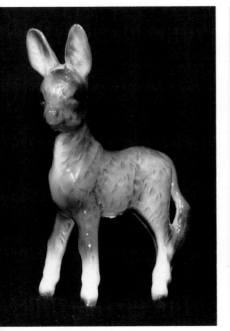

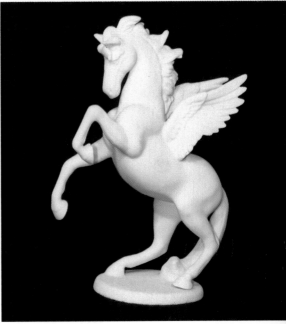

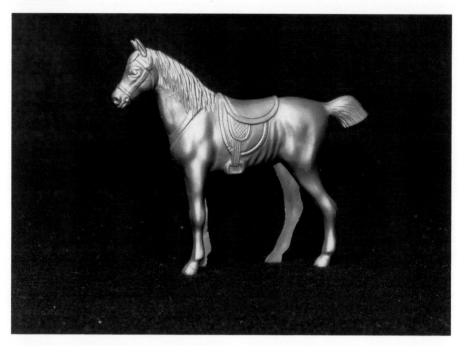

Gold tone standing horse with English tack made in the U.S.A. 5.25". 1942-43. $20-30.

Gold rearing plastic horse by Timmee. 3.5". $4-6.

Gold bucking plastic horse by Timmee. 2.5". $4-6.

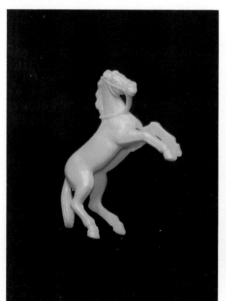

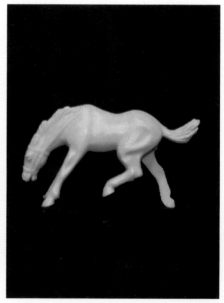

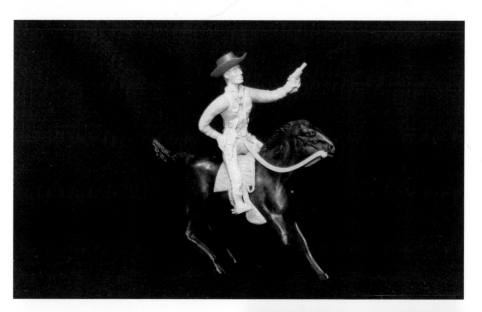

Payton black with tan rider plastic set.
6.25". $25-35.

Palomino horse with rider on base, by
Britains, England. 3". $20-30.

Payton pink with blue rider plastic set.
6.25". $10-15.

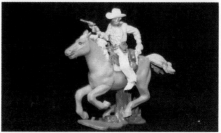

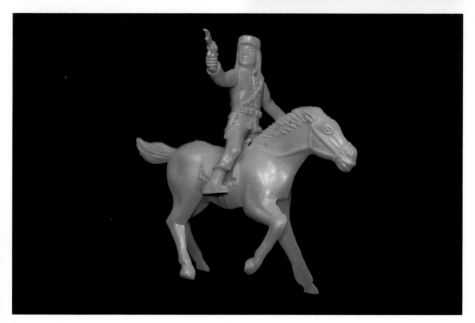

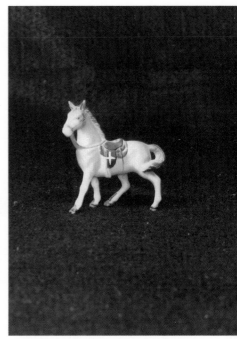

Clydesdales plastic, by Britains, England. 2.5". $10-14.

Brown plastic western horse with saddle. 2.75". $5-8.

White and grey plastic stallion with saddle. 2.75". $5-8.

Tan standing plastic horse from Hong Kong. (#104-5b). 3.25". $1-2.

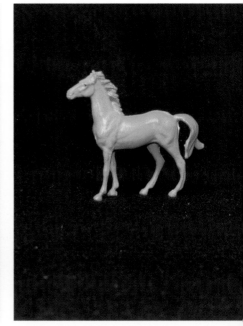

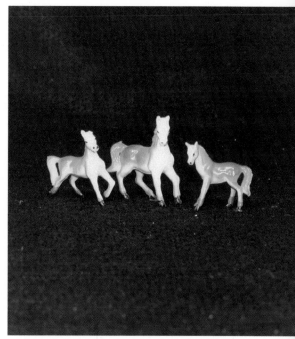

Showcase western mare with foal. 3.5".
$10-14.

Gold plastic mare with 2 foals. 2.5". $6-8.

Brown and white rubber horses by
Auburn Rubber Co. 2.5". $3-4 each.

Pair of white grazing horses. 2.5". $1-2.

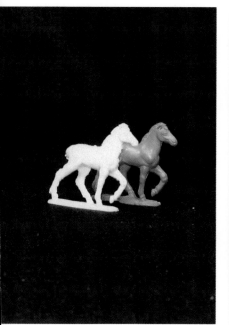

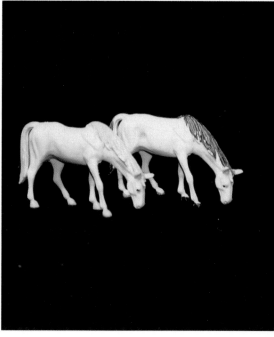

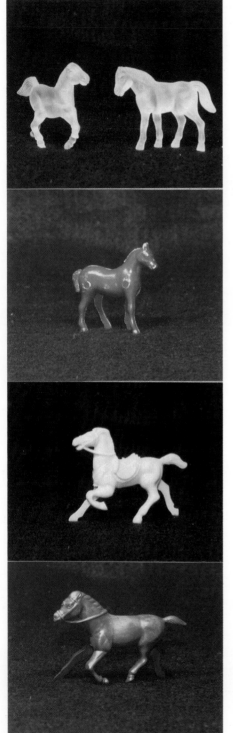

Frosted glass mare and pony. 2.25". $4-6.

Archer blue plastic standing horse. 2.25". $6-10.

Archer grey prancing plastic horse. 2.5". 1950s. $6-10.

Running plastic horse from Rel Plastics. 2.5". $4-7.

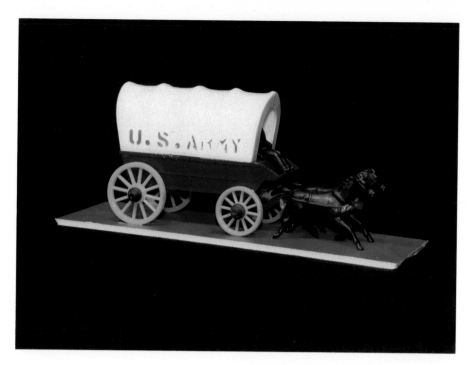

U.S. Army covered wagon with driver and pair of plastic horses from Rel Plastics. 5 ". $25-35.

Plastic prancing pinto pony from Tomy Co. 3". $15-20.

Plastic prancing appaloosa pony from Tomy Co. 3". $15-20.

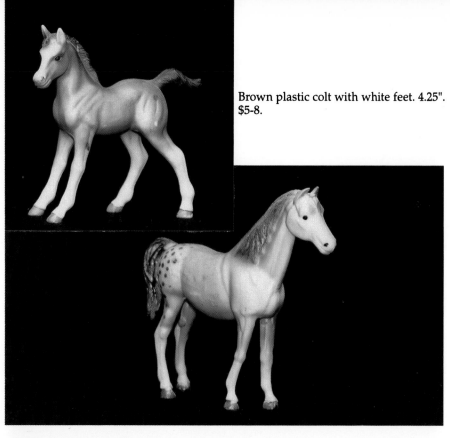

Brown plastic colt with white feet. 4.25". $5-8.

Standing appaloosa plastic horse. 1960s. 5.25". $12-15.

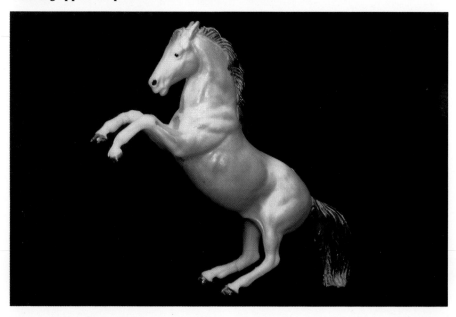

Rearing brown and black horse . 1960s. 6.25". $12-15.

Tan plastic horse with reins. 6.5". $15-20.

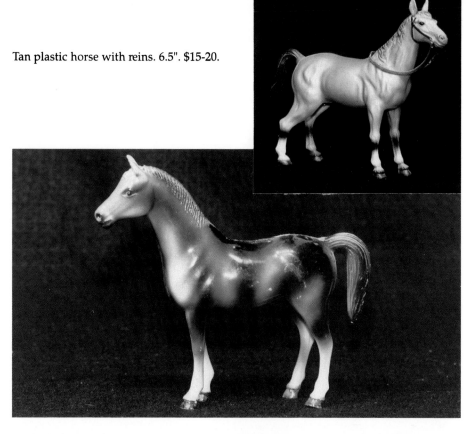

Black plastic standing pony from Hong Kong. 5.5". $8-10.

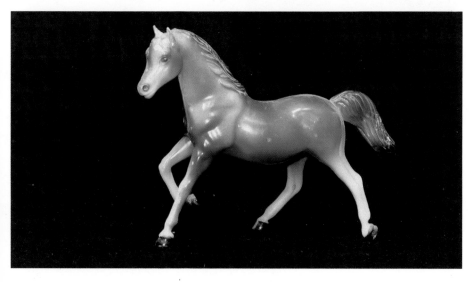

Prancing plastic mare made in Hong Kong. 5". $8-10.

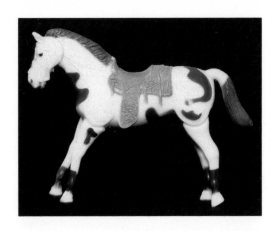

Pinto plastic jointed pony with saddle by Empire Toy Co. 1979. 4". $6-8.

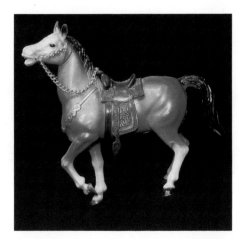

Red and black horse with chain and saddle. 7.25". $15-18.

Solid brown plastic walking horse. 8". $8-10.

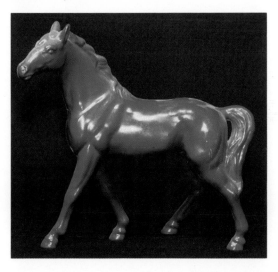

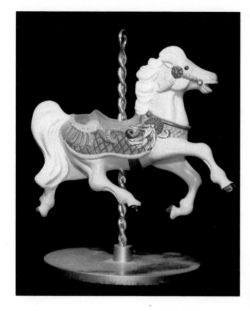

Ginger carousal pony from Hallmark.
1989. 3.5". $6-8.

Black plastic jointed silly horse. 4.5". $2-3.

Star carousal pony from Hallmark.
1989. 3.5". $6-8.

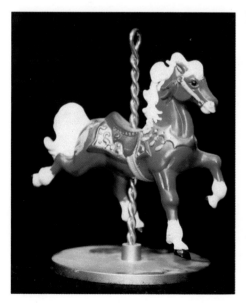

Plastic Fisher-Price jointed toy. 1979. 4.25". $5-8.

Brown pony, premium from fast food
restaurant. 3.5". $2-3.

Plastic pre-school pulling horse toy. 3". $1-2.

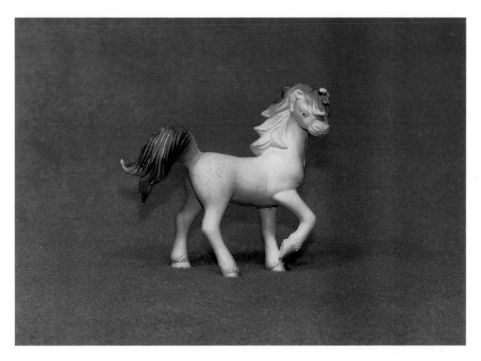

Purple mane rubber unicorn. 3.5". $3-5.

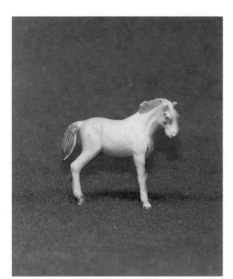

White plastic standing pony made in Hong Kong. 1.5". $1-2.

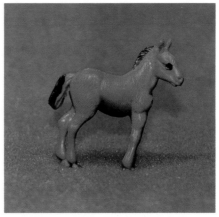

Brown plastic horse. 1.5". $1-2.

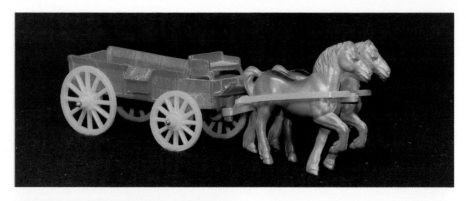

Pair of brown rubber horses pulling a wagon by Auburn Rubber Co. 10" x 3". $40-50.

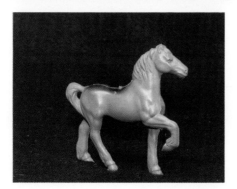

Brown with dark back prancing rubber horse by Auburn Rubber Co. 3.5". $5-7.

Soft white rubber standing horse made in the U.S.A. 4" x 3". $15-20.

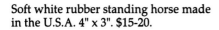

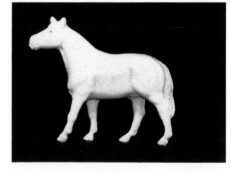

White rearing plastic horse with brown saddle. 2.5". 1950s. $10-15.

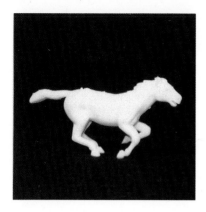

White galloping plastic horse.
1.75". $5-8.

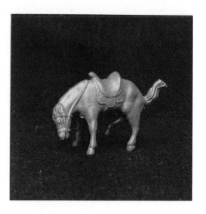

Brown bucking plastic horse with
saddle. 1.75". $8-12.

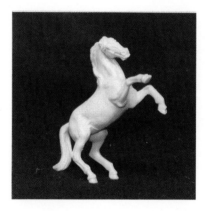

Brown rearing plastic horse with no
saddle. 2.5". 1950s. $10-15.

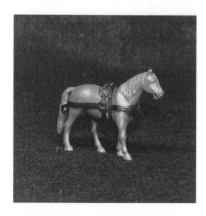

Brown plastic draft horse with tack.
2.5". $6-10.

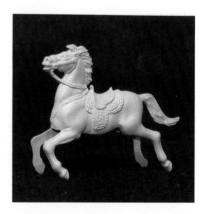

Grey running plastic horse by
Timmee. 3.5" $4-6.

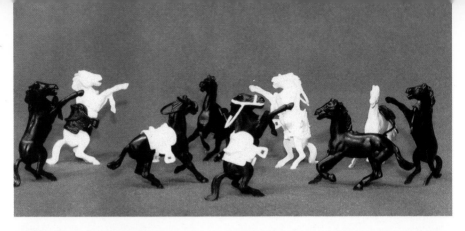

Plastic play set with 9 horses in a corral. 3". $10-15.

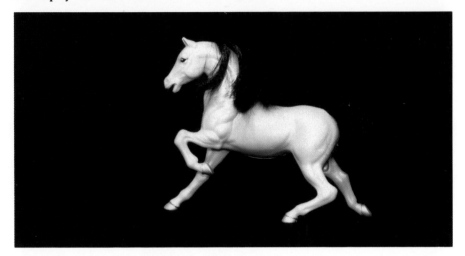

White plastic prancer with real hair. 6 1/2'. $5-8.

Plastic Tennessee standing horse. 4.25". $6-8.

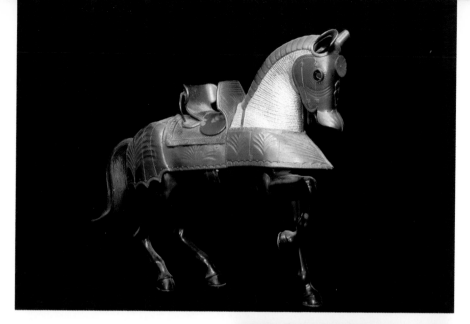

Black plastic horse with metal armor. 8".
$10-12.

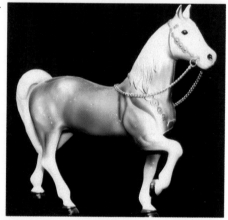

Grey plastic Breyer knock-off with
chain. 7.5". $10-15.

Clydesdale plastic walker. 7.5". $10-15.

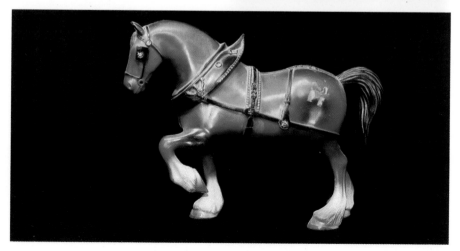

Black crown plastic foal. 2.5". $2-3.

Green plastic pony on base. 1.5" $1-2.

Old white and brown plastic mare with swishing tail. 2.25". $3-4.

Ceramic Burro with rider. 2". $4-6.

Tangerine frost pony. 1.5". $1-2.

Plastic draft horse with brown trim. 1.75". $2-3.

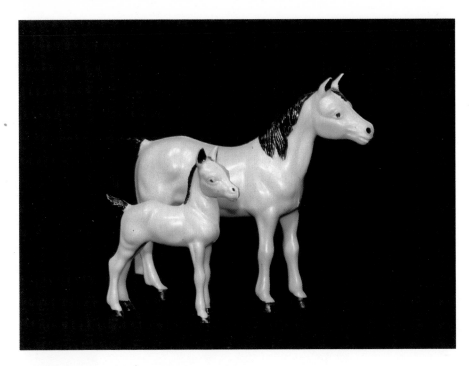

Tan plastic mare and foal by Tonka. 5". $8-10 pair.

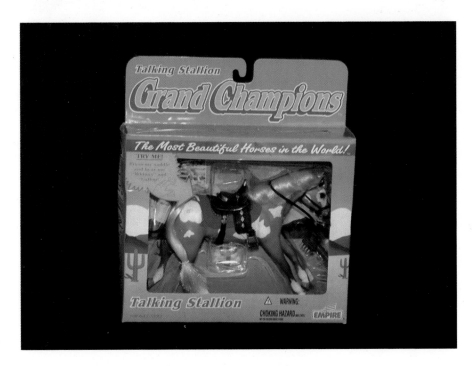

Grand champions talking stallion by Empire. 1994. $10-15.

- Metal

"Outlaw" Remington bronze on marble base. 9.5". $150-200.

"Rattlesnake" Remington bronze on marble base. 9.5". $350-400.

"Wooly Chaps" Remington bronze on marble base. 10". $350-400.

Painted lead standing horse with saddle made by Britains Ltd.-England. 4" x 3". $22-28.

Painted lead cowboy on running horse by Britains Ltd.-England. 3.75" x 2.75". $20-28.

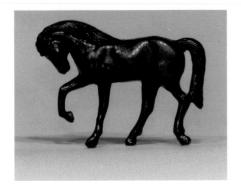

Pot metal Arabian prancing horse. 2.25" x 1.25". $16-20.

Painted lead cowboy on bucking horse by Britains Ltd.-England. 2.5"x 3.5". $22-28.

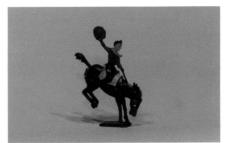

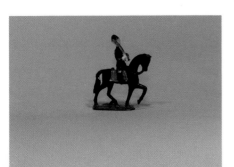

Painted lead black horse with rider. 2" x 2.5". $16-20.

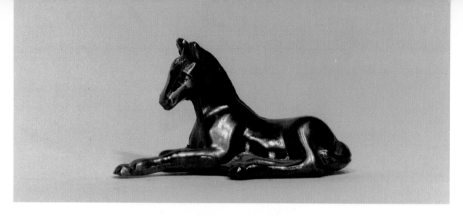

Pewter foal laying down made in Japan. 3.5" x 2". $15-20.

Steel running horse. 1.75" x.75". $15-22.

Pewter pony with a butterfly on its tail. 1.5" x 2.25". $18-22.

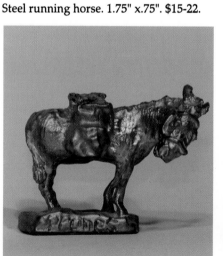

Pewter burro marked "Prunes." 2.5" x 2". $18-22.

Pewter sitting pony. 1.75" x 1". $12-16.

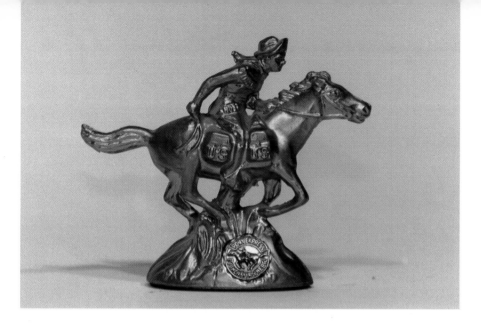

Bronzetone pewter pony express souvenir from Gothenburg, Nebraska. 3.75" x 3.5". $25-32.

Pot metal standing horse, painted bronzetone. 2.5" x 2". $24-30.

Black pot metal, pack burro made in Japan. 2.5" x 2". $15-20.

Souvenir pot metal/coppertone horse from Besty Ross house in Philadelphia. 3.5" x 3". $18-25.

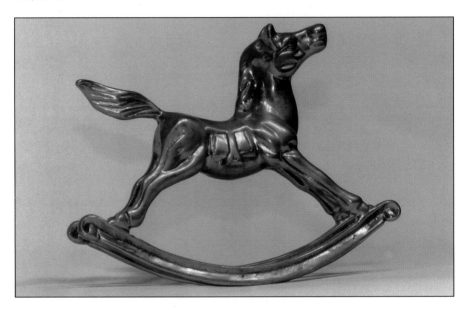

Brass rocking horse. 7.25" x 5.5". $24-28.

Black cast iron pony. 3.5" x 2.75". $15-22.

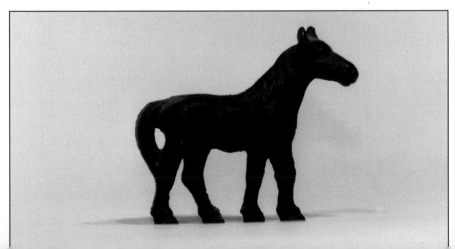

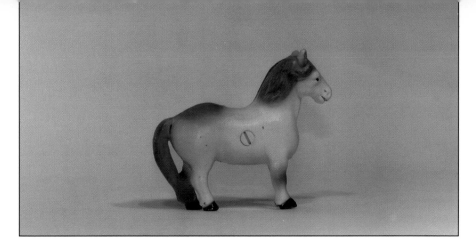

Iron pinto bank. 4.75" x 4 ". $20-28.

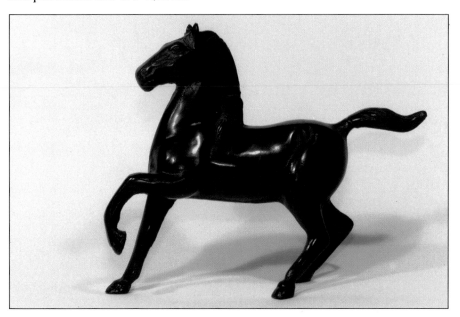

Bronze black painted prancing horse. 8.5" x 7.25". $45-65.

Bronze running horse with saddle. 6.25" x 4". $28-34.

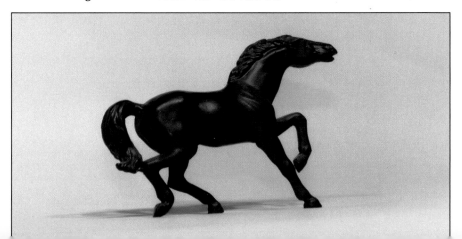

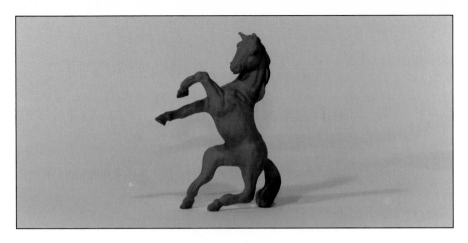

Rearing brown pot metal horse made by Durham Industries Inc. 3". $12-16.

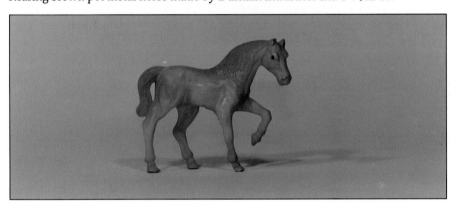

Yellow/orange walking horse made by Durham Industries Inc. 1977. 3.25" x 3.5". $10-15.

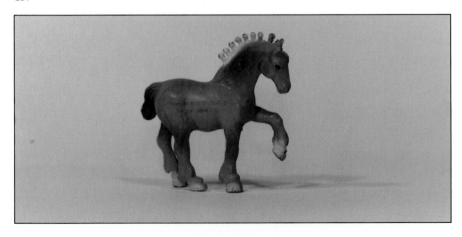

Tan draft horse with pinned mane. Made by Durham Industries Inc., 1977. 2.75" x 2.5". $10-15.

Gray draft horse with pinned mane. Made by Durham Industries Inc., 1977. 2.75" x 2.5". $10-15.

Hand made folk art horse, made of nails. 4.5" x 4.5". $15-22.

Painted metal horse. 2.75" x 2.5". $6-10.

Painted pot metal strutting horse with chain. 2.75" x 2.5". $6-10.

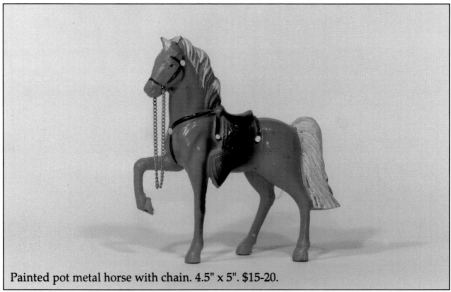

Painted pot metal horse with chain. 4.5" x 5". $15-20.

Pot metal standing horse marked Japan. 2.5" x 2". $6-10.

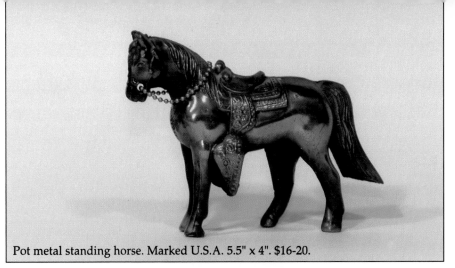

Pot metal standing horse. Marked U.S.A. 5.5" x 4". $16-20.

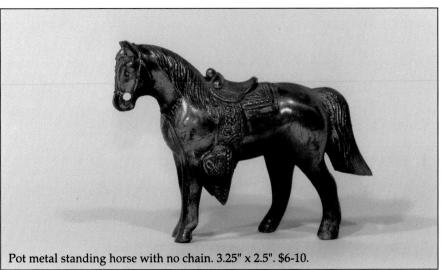

Pot metal standing horse with no chain. 3.25" x 2.5". $6-10.

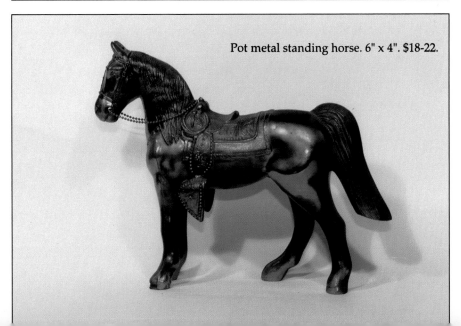

Pot metal standing horse. 6" x 4". $18-22.

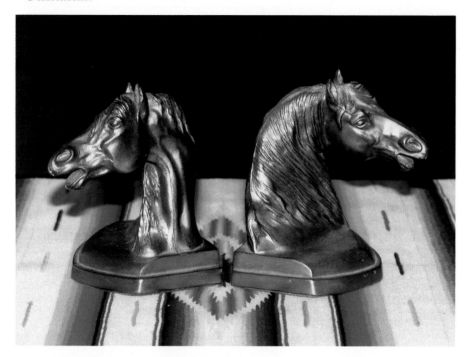

Bronze horse bust bookends. 4" x 6". $75-100.

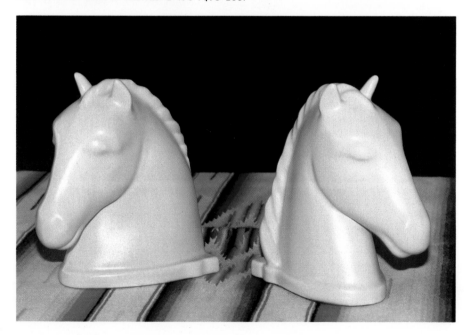

Abbingdon horse bust bookends. 7". $100-125.

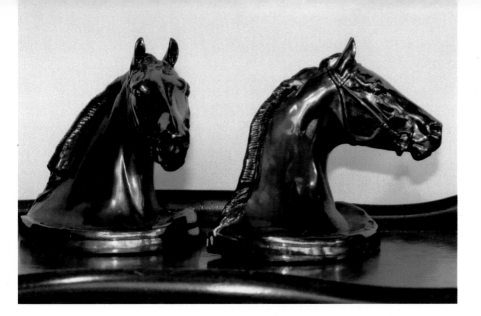

Brass coppertone horse busts bookends. 6.5". $75-100 pair.

Sascha B candy dish. 6". $25-35.

Brass full body horse bookends from Frankart. 5.25". $150-200 pair.

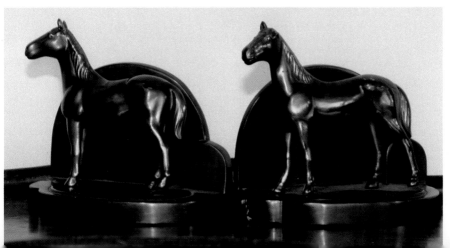

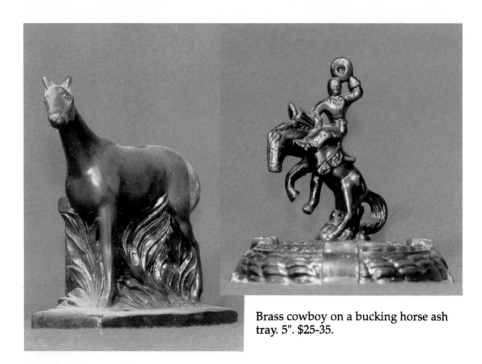

Brass cowboy on a bucking horse ash tray. 5". $25-35.

Brass bookend horse on a base. 6.25". $8-12.

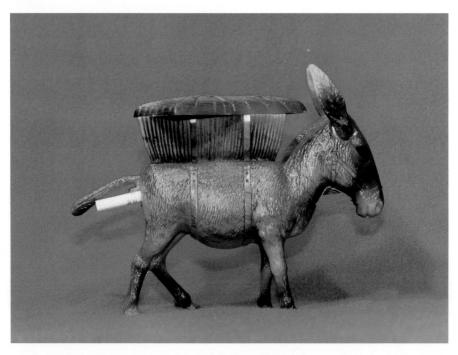

Plastic donkey cigarette dispenser and holder. 6.5". $30-35.

Plastic horse standing on glass horse-shoe ashtray. 3". $5-8.

Milk glass sitting horse candy dish. 4.5". $16-22.

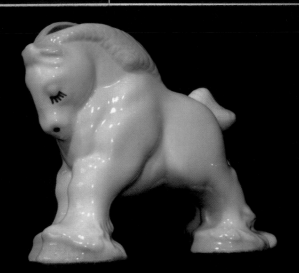

Draft horse planter. 5.25". $8-12.

Clear glass rocking horse candle holder. 2.5". $5-10.

Pink and black glass candy dish. 3.5". $40-50.

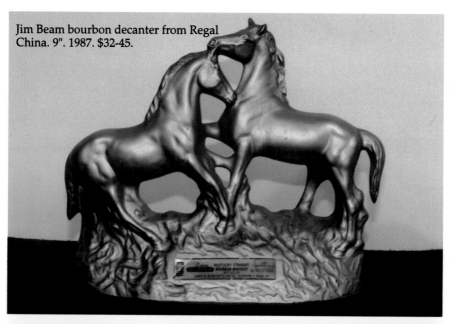

Jim Beam bourbon decanter from Regal China. 9". 1987. $32-45.

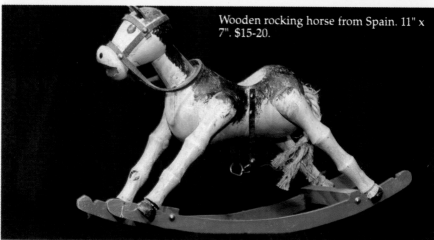

Wooden rocking horse from Spain. 11" x 7". $15-20.

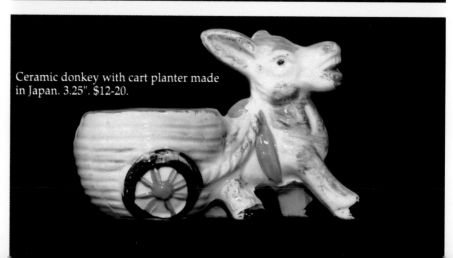

Ceramic donkey with cart planter made in Japan. 3.25". $12-20.

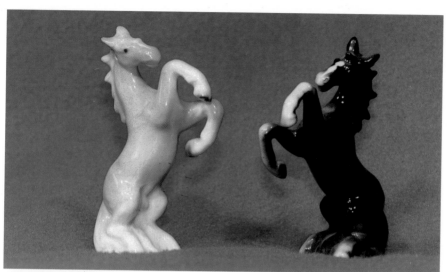

Rearing horses salt and pepper set. Blue sticker Japan. 4.5". $15-20.

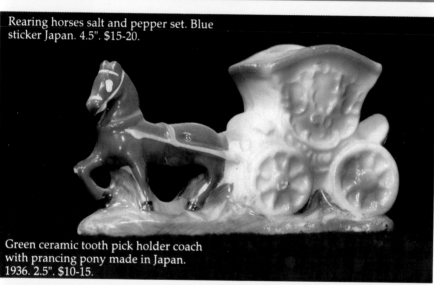

Green ceramic tooth pick holder coach with prancing pony made in Japan. 1936. 2.5". $10-15.

Donkey chalk salt and pepper set. 2.5". $7-10.

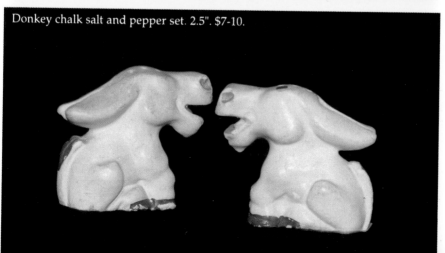

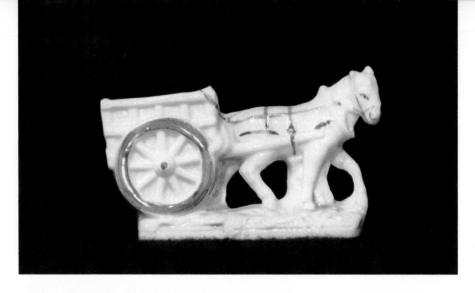

Ceramic pony with cart tooth pick holder. 2.25". $5-8.

Ceramic highly glazed horse with Conestoga wagon tooth pick holder. 2.5". $5-8.

Ceramic highly glazed horse with Conestoga wagon tooth pick holder. 3.5". $10-15.

Ceramic girl leading pony with a cart tooth pick holder made in Japan. 3". $12-15.

Ceramic donkey with cart tooth pick holder made in Japan. 2.5". $12-15.

Wooden pony with cart tooth pick holder. 2.75". $3-5.

Pressed wood pipe holder with horse embossed in center. $30-40.

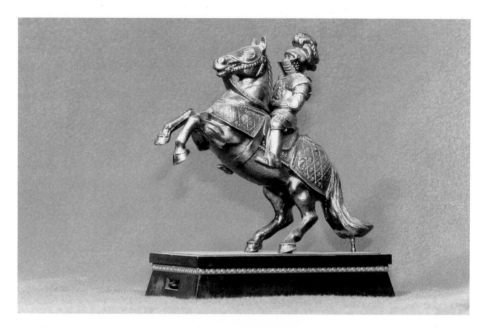

Pewter and plastic radio made in Japan. 8.75". $20-30.

Cream perfume container of a resting pony by Tojours Moi. 1.75". $6-10.

Three piece black horse ceramic lamp and side dishes. Plastic shade. 1950s. 23". $65-75.

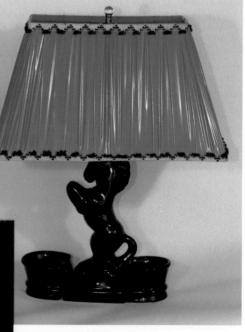

Stone art carved horse bust business card holder. 1960s. $25-35.

- Caricature

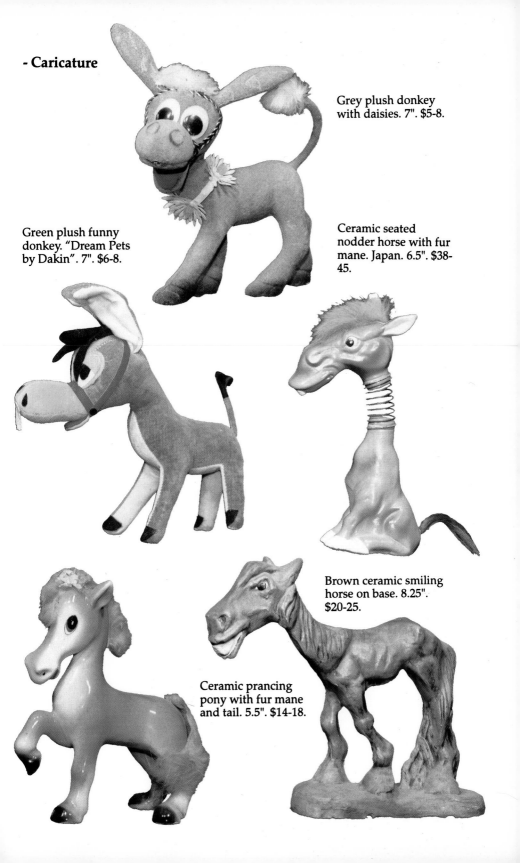

Grey plush donkey with daisies. 7". $5-8.

Green plush funny donkey. "Dream Pets by Dakin". 7". $6-8.

Ceramic seated nodder horse with fur mane. Japan. 6.5". $38-45.

Brown ceramic smiling horse on base. 8.25". $20-25.

Ceramic prancing pony with fur mane and tail. 5.5". $14-18.

- Advertising

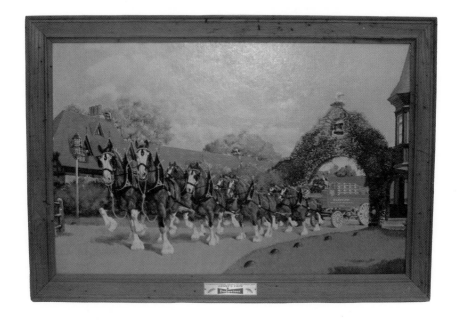

Budweiser Clydesdale sign from Grants Farm. 29" x 42.5". $225-275.

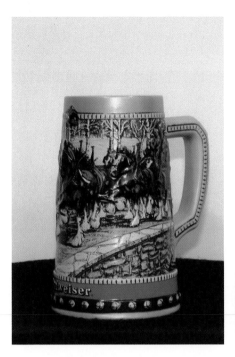

Budweiser holiday stein. 1988. 7". $15-20.

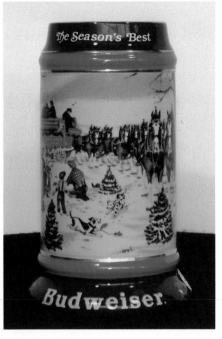

Budweiser holiday stein. 1991. 7". $15-20.

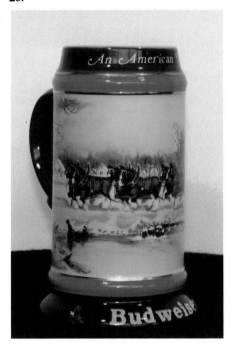

Budweiser holiday stein. 1990. 7". $15-20.

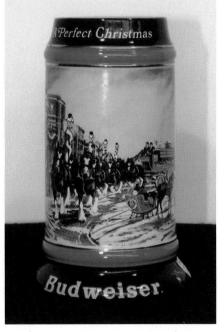

Budweiser holiday stein. 1992. 7". $15-20.

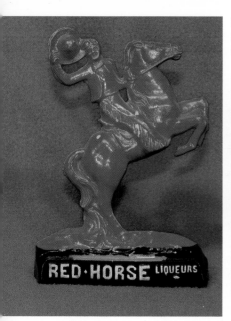

Red Horse Liqueurs composition advertising statuettes, New York City. 6.5" x 9.5". $75-90.

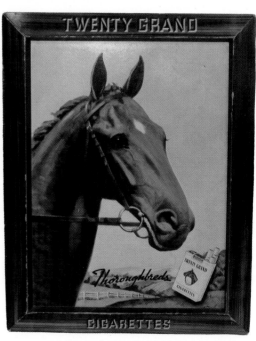

White Horse Scotch Whiskey advertising with white and cream color plastic. 5" x 6". $35-45.

Cardboard Twenty Grand Cigarette sign. 31" x 25". $250-300.

Black Horse Ale plastic horse advertising from Black Horse Brewery, New Jersey. 10" x 8". $50-65.

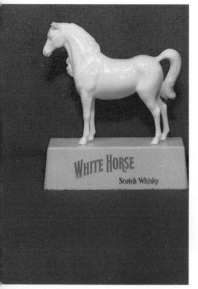

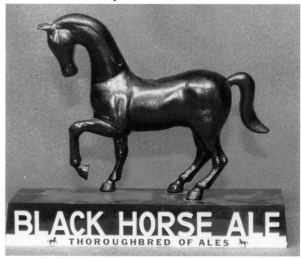

- Carousel Horses, Rocking Horses and Other Ride Upon Horses.

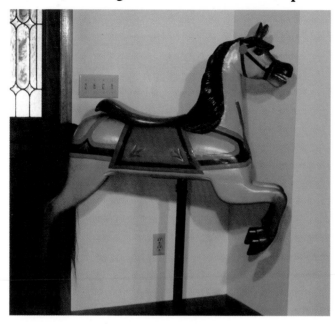

Flying wooden carousel horse with carved bird seat and horsehair tail. 1883. 39" x 43" long. 1883. $7,000 and up. (Insert of details of head)

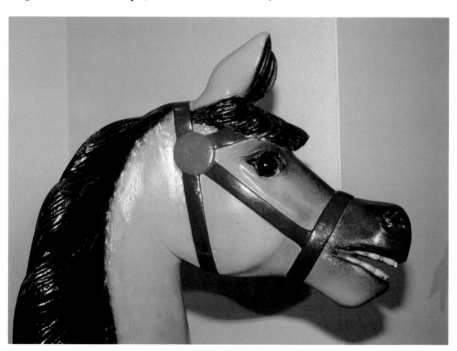

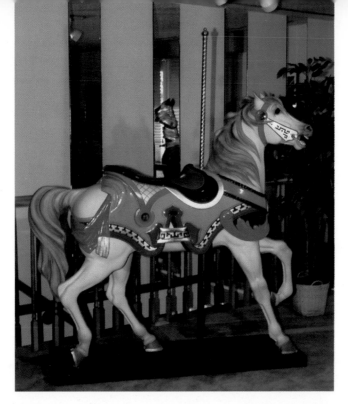

Stander, white wooden carousel horse. John Zalar carver. Philadelphia Toboggan Co. From a carousal in Germantown, Pa. 58" x 59" long. 1922. $35,000 and up. (Insert of details of head)

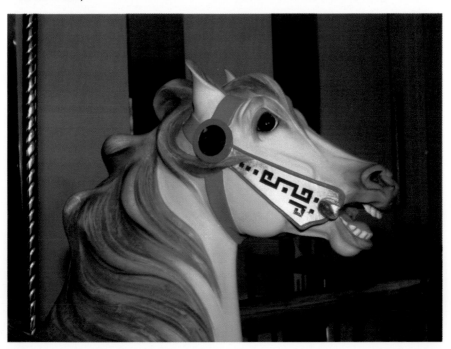

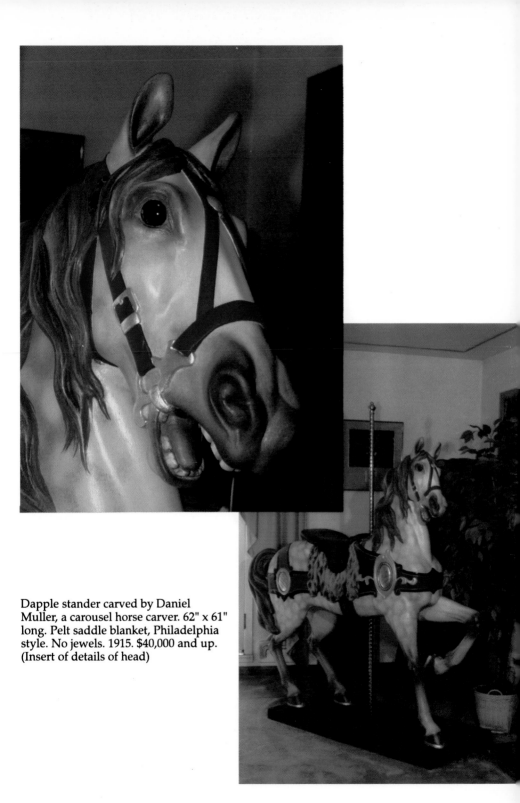

Dapple stander carved by Daniel Muller, a carousel horse carver. 62" x 61" long. Pelt saddle blanket, Philadelphia style. No jewels. 1915. $40,000 and up. (Insert of details of head)

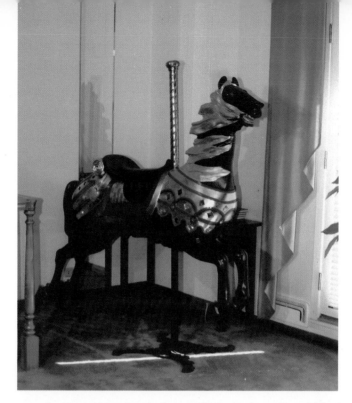

Black jumper in the Coney Island style from 1910. Lots of jewels, gold leaf and glitz. Stylized short ears and real horse shoes. 53" X 66" long. $30,000. (Insert of details of the head.)

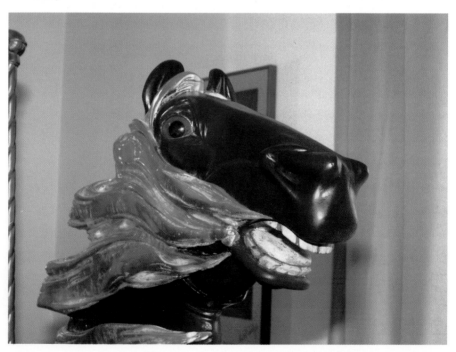

Wooden fur covered rocking horse. 1930s. $165-185.

Wooden doll's rocking horse. 11". $35-45.

Hand made child's wooden rocking horse. 1930s. $85-100.

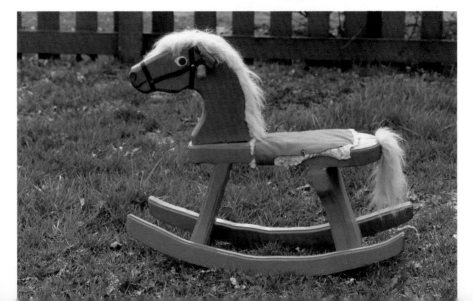

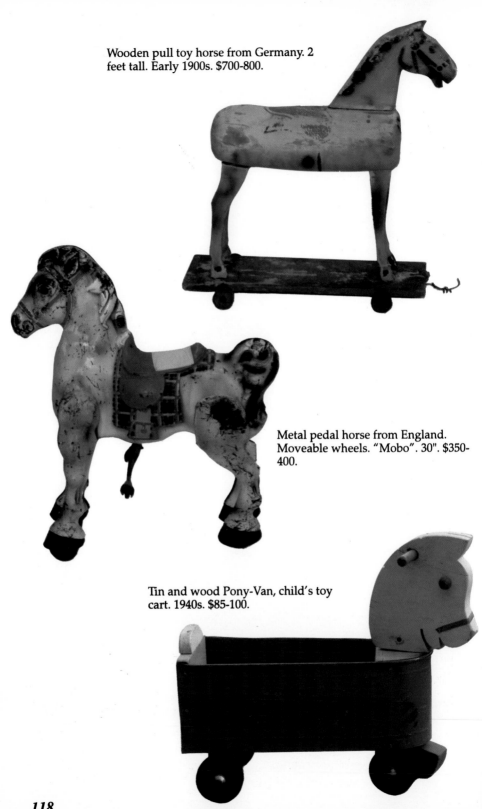

Wooden pull toy horse from Germany. 2 feet tall. Early 1900s. $700-800.

Metal pedal horse from England. Moveable wheels. "Mobo". 30". $350-400.

Tin and wood Pony-Van, child's toy cart. 1940s. $85-100.

Part 3: Horses Around The World

- Asia

Blue ceramic standing figural horse. 3". $18-22.

Gold ceramic figural horse with blue base marked "China 44". 6" x 6". $16-22.

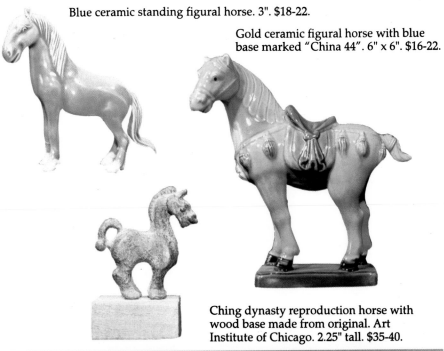

Ching dynasty reproduction horse with wood base made from original. Art Institute of Chicago. 2.25" tall. $35-40.

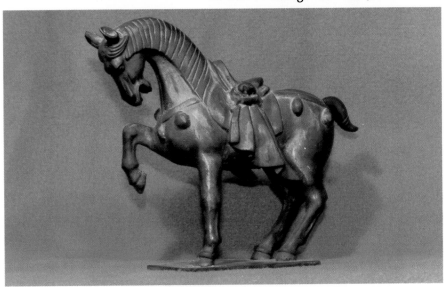

Oriental bronze, coppertone saddled Trojan type horse. 10". $195-250.

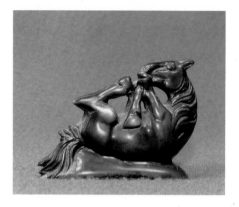

Figural horse lying on its back, carved stone. 1961. 2.5". $35-40.

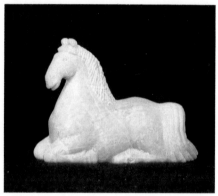

Carved soapstone figural horse. 3.25". $35-40.

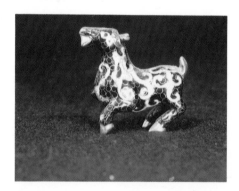

Cloisonne figural horse. 1.75". $23-30.

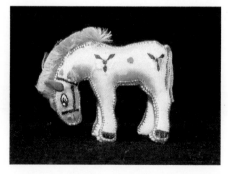

Blue plush pony with pink fur mane, made in China. 2". $6-10.

Dark green plush toy pony with fur mane. Made in China. 3". $6-10.

Green plush horse with fur mane, marked China. 2". $6-10.

Fat plush red horse, marked China. 3". $10-15.

Yellow plush horse from China, 3". $6-10.

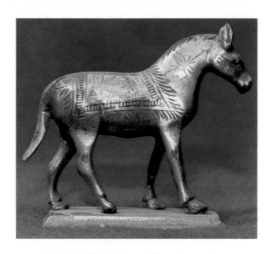

Decorated brass standing horse from
India. 3.5". 1960s. $18-22.

Brass horse with colt from India. 6.75". $50-65.

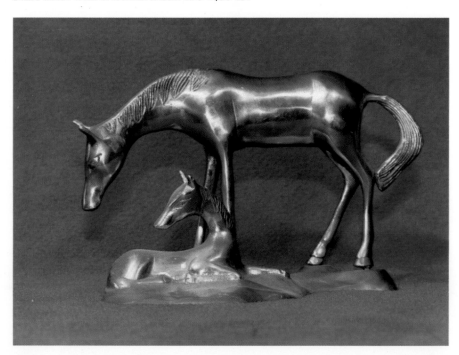

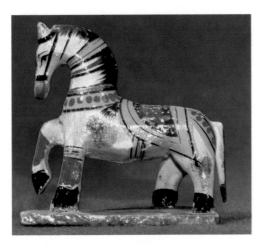

Papier mache colorful prancing horse
from India. 4". 1960s. $28-34.

Hand woven 100% cotton standing horse from India. 5.75". 1960s. $26-32.

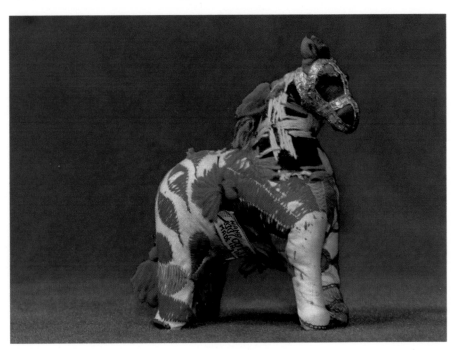

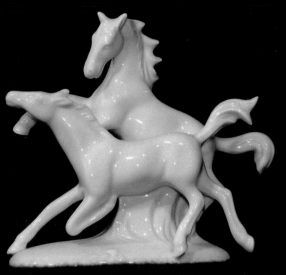

White ceramic pair of galloping horses marked with blue Crown from Germany. 4.5". $30-40.

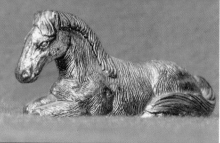

Pewter resting horse made in Spain. 1.5". $6-10.

Furry wind up circus horse marked West Germany, monkey face mark. 9". $85-100.

Fuzzy brown standing horse marked West Germany. 2.5". $8-12.

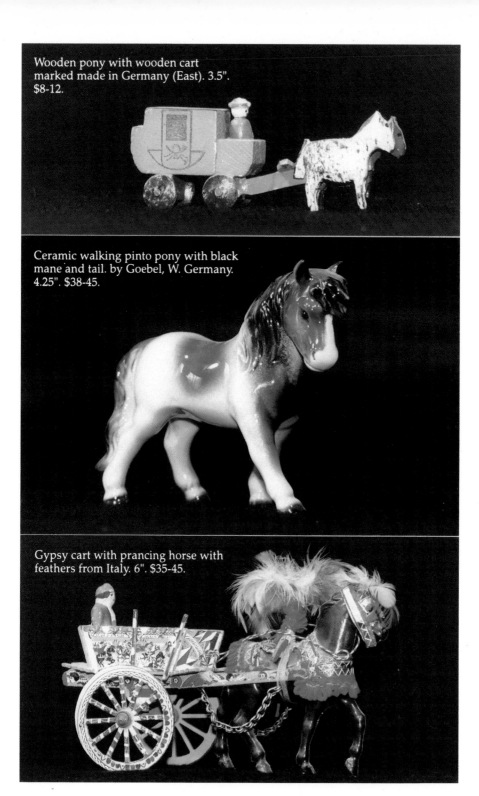

Wooden pony with wooden cart
marked made in Germany (East). 3.5".
$8-12.

Ceramic walking pinto pony with black
mane and tail. by Goebel, W. Germany.
4.25". $38-45.

Gypsy cart with prancing horse with
feathers from Italy. 6". $35-45.

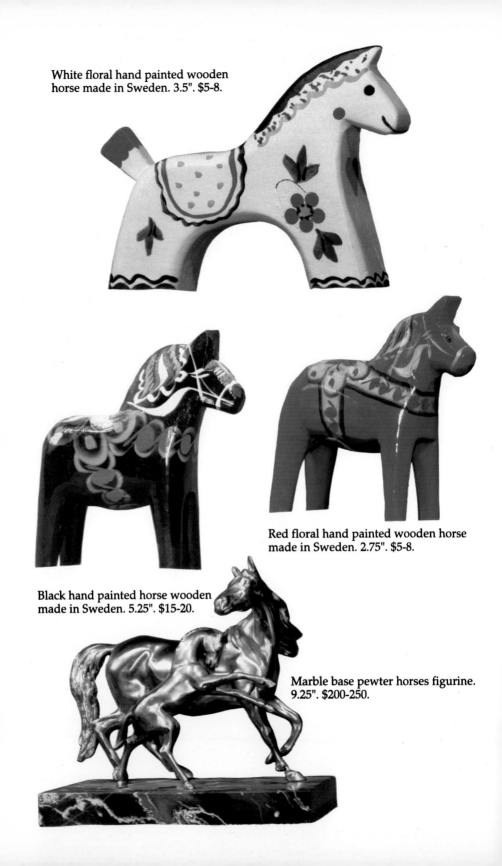

White floral hand painted wooden
horse made in Sweden. 3.5". $5-8.

Red floral hand painted wooden horse
made in Sweden. 2.75". $5-8.

Black hand painted horse wooden
made in Sweden. 5.25". $15-20.

Marble base pewter horses figurine.
9.25". $200-250.

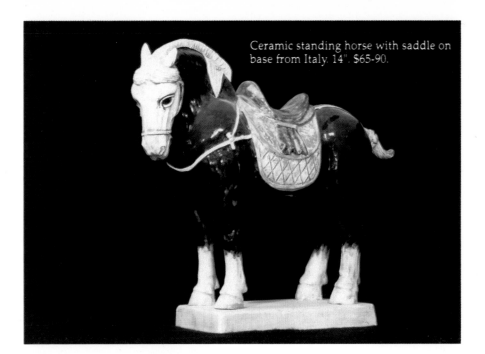

Ceramic standing horse with saddle on base from Italy. 14". $65-90.

-Africa

Ivory standing horse on wood base from Kenya. 1972. .75" x .75". $32-40.

Wooden zebra from Kenya. 1.25". $6-10.

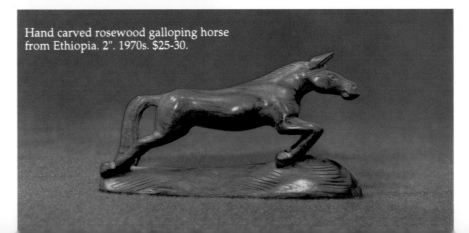

Hand carved rosewood galloping horse from Ethiopia. 2". 1970s. $25-30.

Reproduction Mesopotamian metal
horse with wood base. 1.75". $34-38.

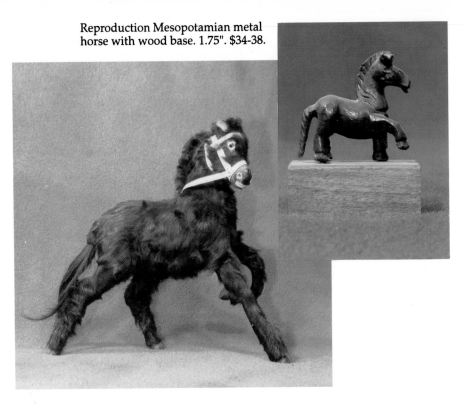

Brown galloping horse covered with
real horse fur, from Morocco. 12" x 12".
$42-48.

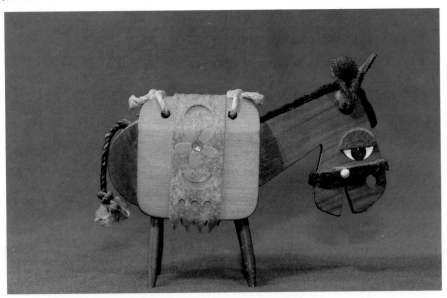

Wood donkey with felt saddle from Israel. 5". 1970s. $25-30.

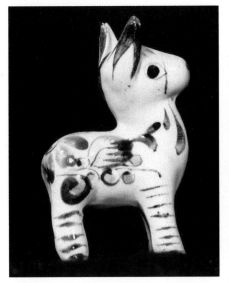

Ceramic standing horse from Mexico. 3". $5-8.

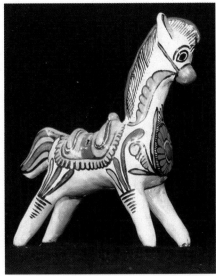

Colorful pottery bank from Mexico. 8". $20-25.

Pink quartz sitting burro. 1.75". $2-4.

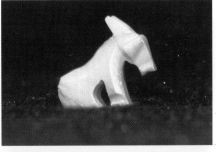

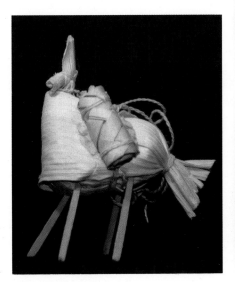

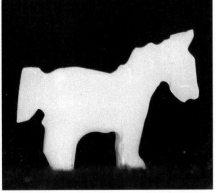

Corn husk hand made horse from Mexico. 3". $15-20.

Carved quartz standing horse. 3". $3-5.

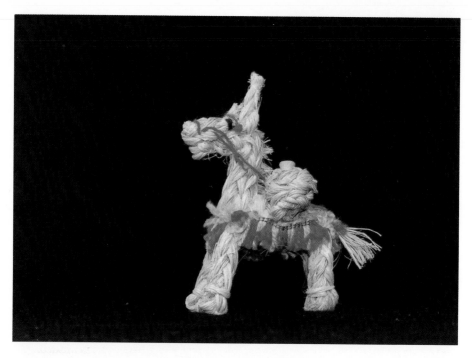

Rope hand made standing horse from Mexico. 5.5". $15-20.

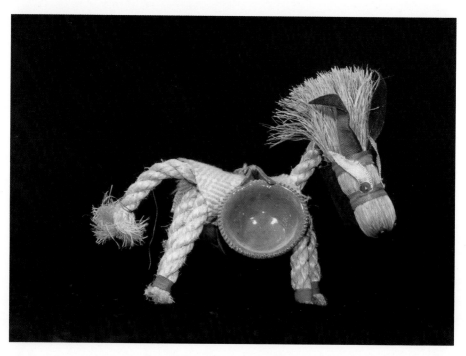

Rope horse with broom head from Mexico. 5". $15-20.

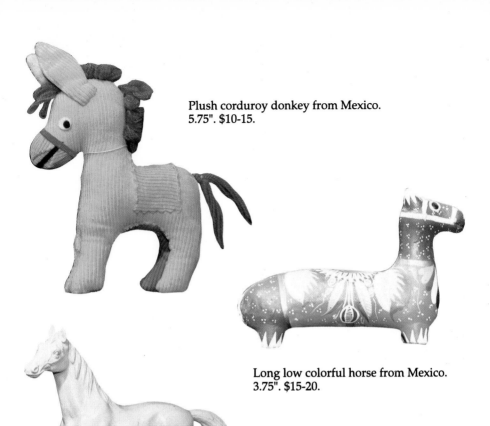

Plush corduroy donkey from Mexico.
5.75". $10-15.

Long low colorful horse from Mexico.
3.75". $15-20.

White plaster/resin horse on base from
Mexico. 9.25". $25-30.

Raw rubber cowboy on horse, toy. 2
separate pieces. 6.5". $25-35.

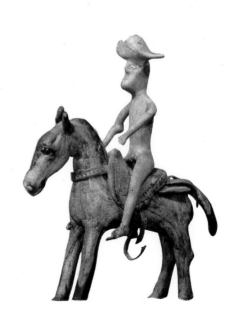

Part 4: Collecting Celebrity Horses

-Beneath Every Great Cowboy Theres A Great Horse - Trigger, Silver, Scout, Champion, Etc.

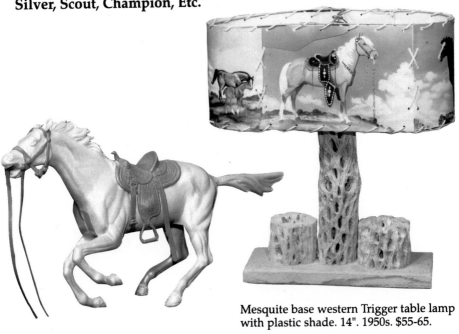

Mesquite base western Trigger table lamp with plastic shade. 14". 1950s. $55-65.

Gold running model plastic Trigger with detachable saddle. Made in Germany. 1960s. 7.5"/ $45-65 without Roy.

Hartland Trigger. 8". $20-25.

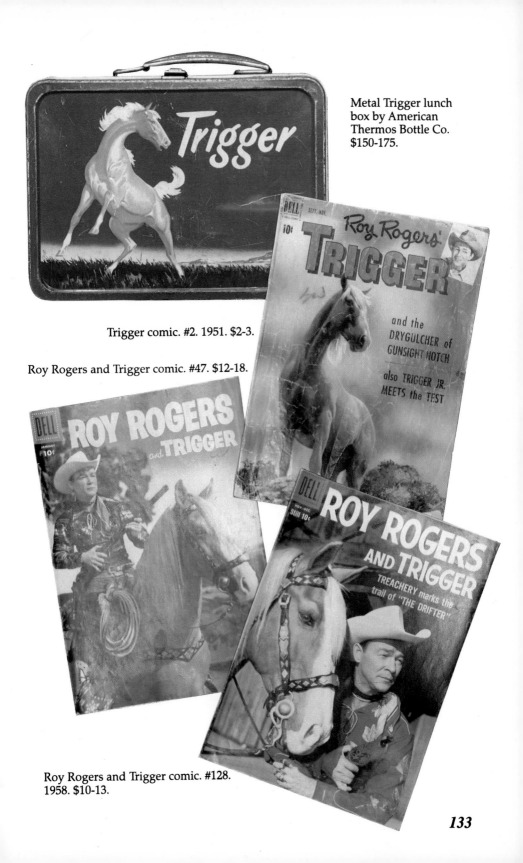

Metal Trigger lunch box by American Thermos Bottle Co. $150-175.

Trigger comic. #2. 1951. $2-3.

Roy Rogers and Trigger comic. #47. $12-18.

Roy Rogers and Trigger comic. #128. 1958. $10-13.

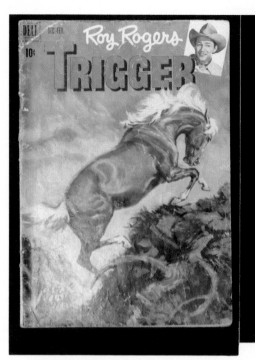

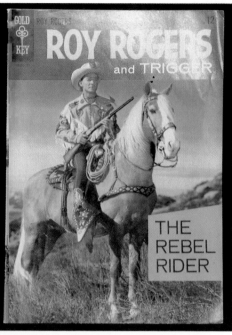

Trigger comic.#3. 1952. $3-5.

Roy Rogers and Trigger comic. #1. 1958. $20-25.

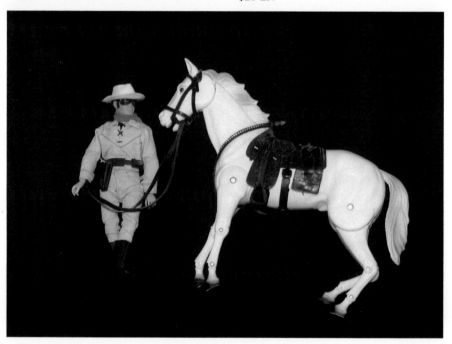

Silver and the Lone Ranger, articulated plastic action figures by Gabriel. 12". 1973. $40-50.

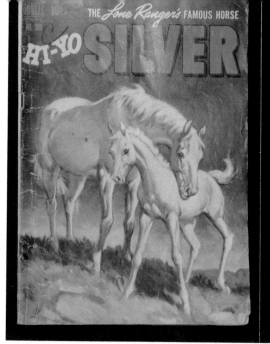

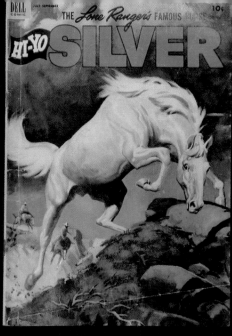

Silver comic. #1. (#369 four color.) 1951.
$10-15.

Silver comic. #7. 1953. $4.50-6.

Silver comic. #2. (#392 four color.) 1952.
$5-7.

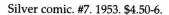

Silver comic. #14. 1955. $3.50-5.

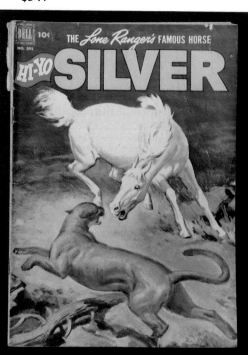

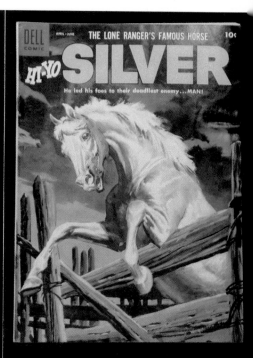

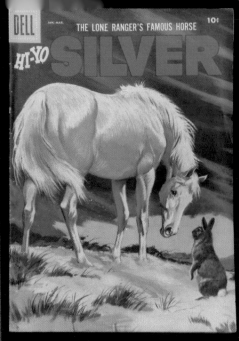

Silver comic. #16. 1955. $3.50-5.

Silver comic. #17. 1955. $3.50-5.

Silver comic. #21. 1956. $7-9.

Silver comic. #26. 1958. $8-10.

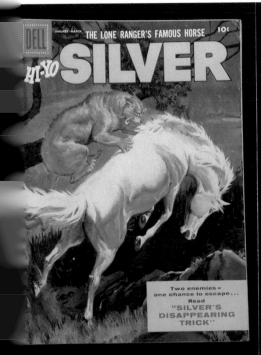

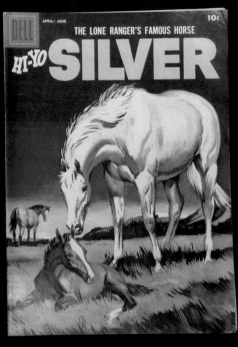

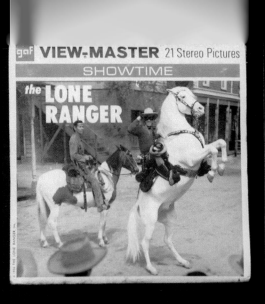

Lone Ranger View Master pictures.
1956. $25-30.

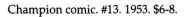

Champion comic. #13. 1953. $6-8.

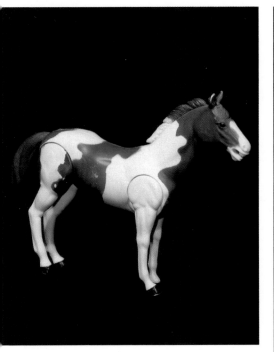

Plastic jointed Scout, Tonto's pinto.
1980. Lone Ranger Ltd. $18-22.

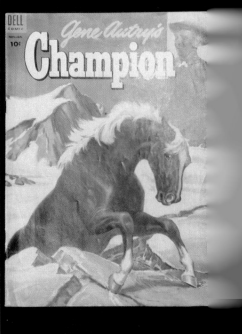

Champion comic. #12. 1953. $6-8.

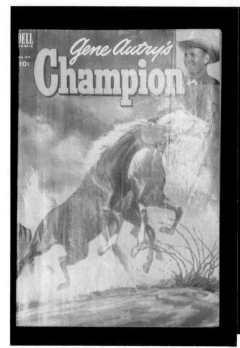

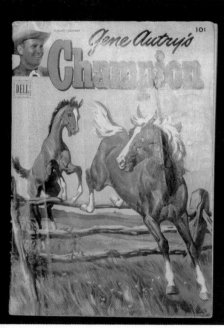

Champion comic. #11. 1953. $4-6.

Gene Autry's horse Champion comic. #7. 1952. $4-6.

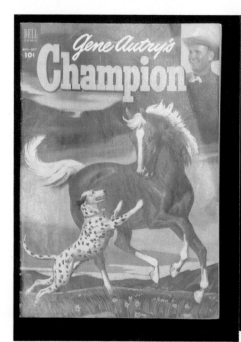

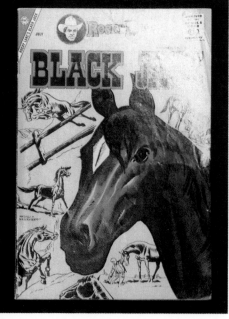

Champion comic. # 10. 1953. $6-8.

Rocky Lane's horse Black Jack comic. #23. 1958. $10-13.

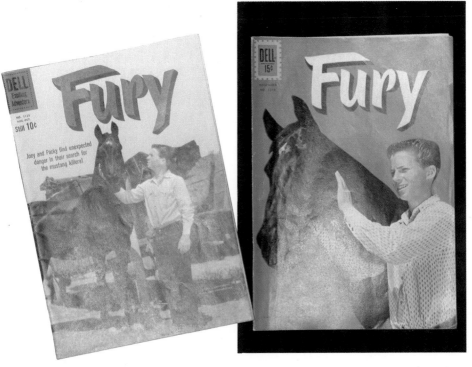

Fury comic by Dell. #1133. 1960. $30-40.　　　Fury comic by Dell. #1218. 1961. $15-18.

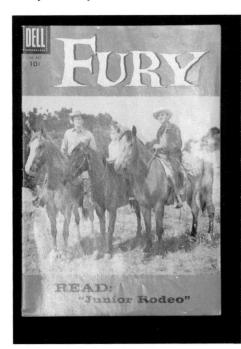

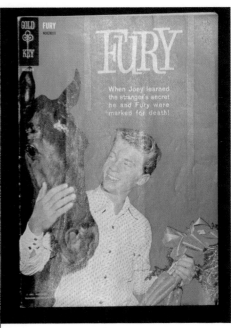

Fury comic by Dell. #888. 1958. $16-20.

Fury comic by Gold Key. #1. 1962. $18-22.

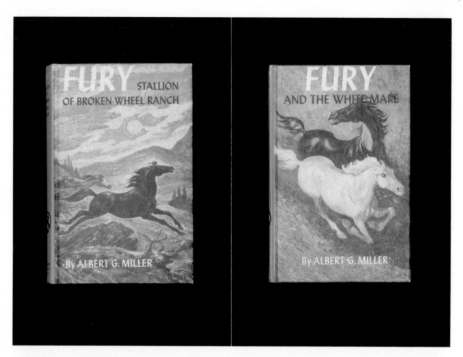

Black Fury of broken wheel ranch, story book by Albert Miller. $4-6.

Black Fury and the White Mare, book by Albert Miller. $4-6.

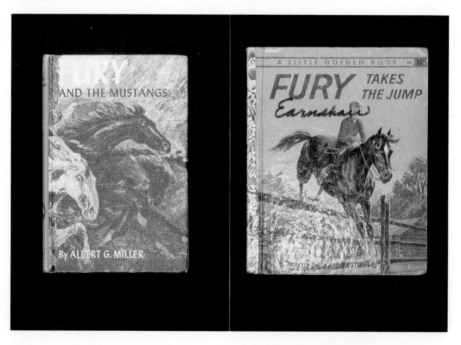

Black Fury and the Mustangs book, by Albert Miller. $4-6.

Fury Takes the Jump book by Little Golden Books. 1958. $8-10.

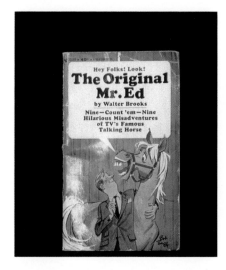

The Original Mr. Ed by Bantam Books and Walter Brooks. 1963. $14-20.

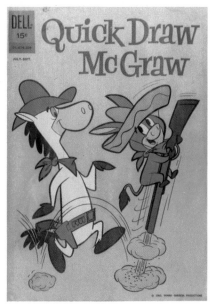

Quick Draw McGraw comic by Dell. #11. 1962. $11-15.

Quick Draw McGraw comic by Charlton. #5. 1971. $6.50-7.

Quick Draw McGraw comic by Dell. #3. 1960. $13-15.

Quick Draw McGraw book. 1972.
Hanna Barbera. $3-4.

Baba Looey plastic bank from Quick
Draw McGraw. 1960s. $20-24.

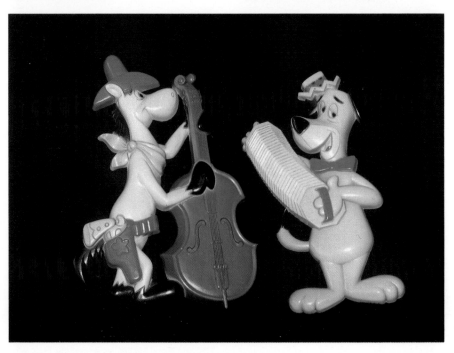

Plastic Quick Draw Mcgraw wall hanger. $25-25.

National Velvet comic by Gold Key. #2.
1963. $7-10.

Francis the Talking Mule comic by Dell.
#655. 1955. $8-10.

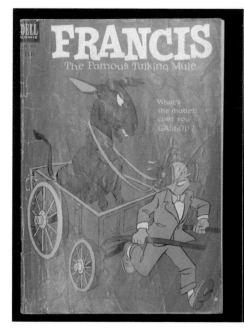

Francis the Talking Mule comic. #4-C-
501. 1953. $10-14.

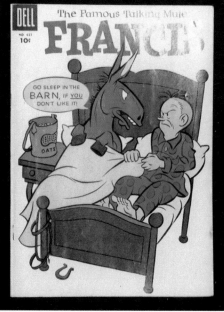

Francis the Talking Mule comic by Dell.
#621. 1955. $10-13.

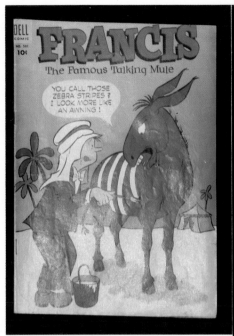

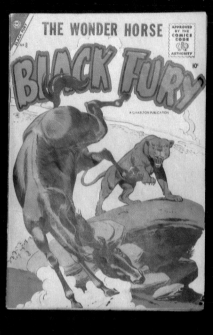

Francis the Talking Mule comic by Dell.
#465. 1953. $6-8.

Black Fury comic. #8. 1956. $2.50-3.50.

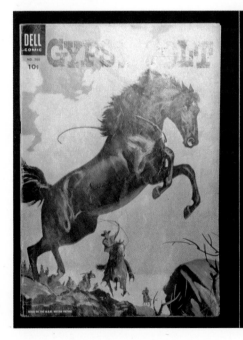

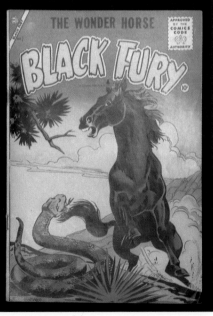

Gypsy Colt by Dell. 4-C #568. 1954. $10-14.

Black Fury comic the wonder horse by Charlton Comics. #7. 1956. $2.50-3.50.

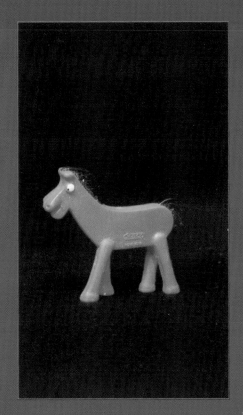

Plastic mini Pokey by Jesco. $3-5.

Plastic Pokey. Mint on card by Jesco. $5-6.

-Chincoteague Ponies

Misty, plastic Breyer horse. 6.75". $25-35.

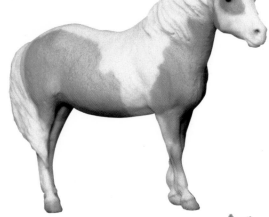

Chincoteague plastic pony farm stickers. $10-15.

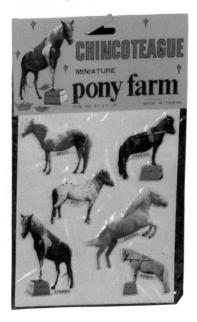

Stormy, plastic Breyer horse. 5.75". $20-25.

Misty and Stormy story books by Rand McNally. $10-12 each.

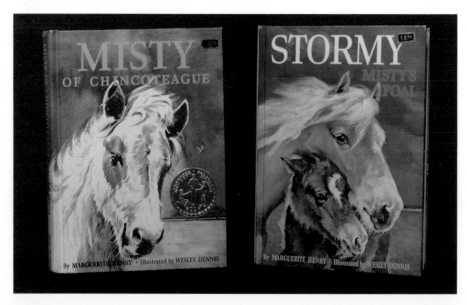

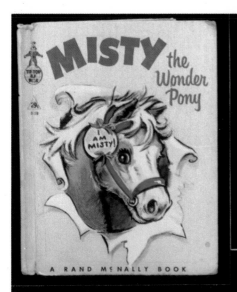

Misty the Wonder Pony story book by Rand McNally. $10-15.

Misty's hoofograph printed. Available at Chincoteague-Misty museum. $10-15.

Misty, plastic horse with post card and model pony club application from Chincoteague. 6.25". $20-25.

Miniature plastic pony farm by Chincoteague, Virginia. 1". $25-30.

Part 5: Miscellaneous Collectible Horses

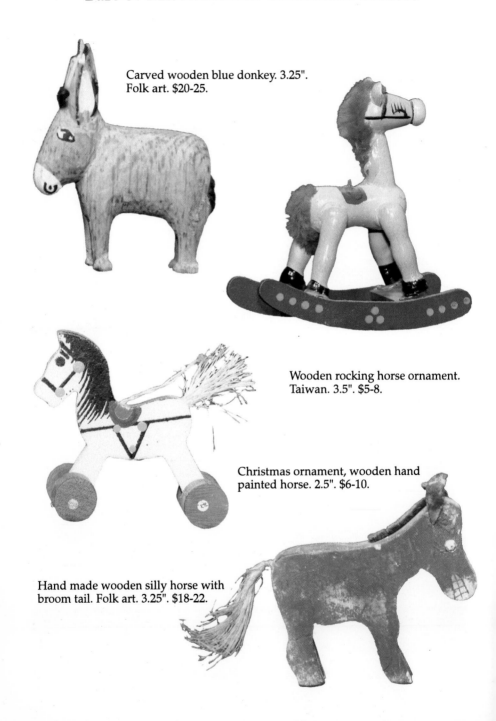

Carved wooden blue donkey. 3.25".
Folk art. $20-25.

Wooden rocking horse ornament.
Taiwan. 3.5". $5-8.

Christmas ornament, wooden hand
painted horse. 2.5". $6-10.

Hand made wooden silly horse with
broom tail. Folk art. 3.25". $18-22.

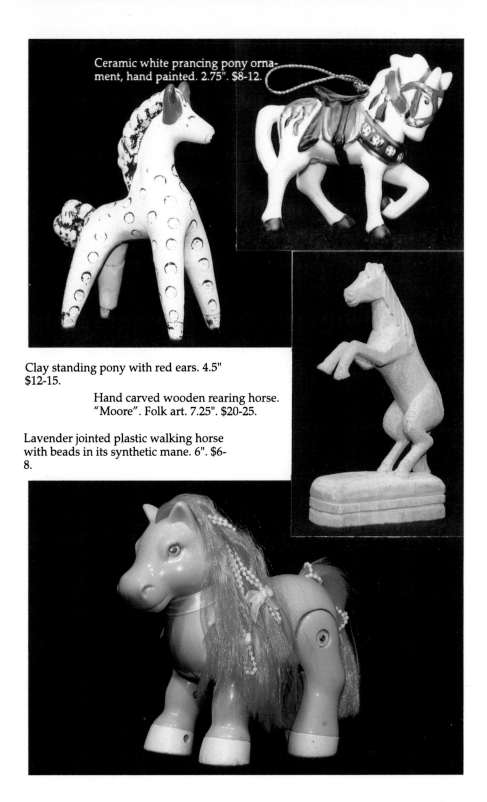

Ceramic white prancing pony ornament, hand painted. 2.75". $8-12.

Clay standing pony with red ears. 4.5" $12-15.

Hand carved wooden rearing horse. "Moore". Folk art. 7.25". $20-25.

Lavender jointed plastic walking horse with beads in its synthetic mane. 6". $6-8.

Unmarked brush and comb mane standing rubber horse. 3.5". $1-2.

Dallas-palomino with saddle, Barbie's pony by Mattel. 1970s. 11". $30-40.

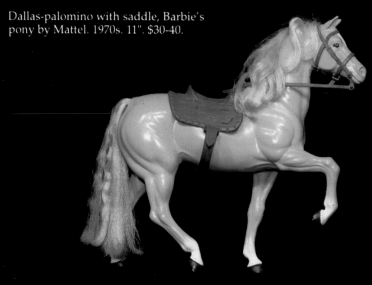

Dixie-Dallas foal, Barbie's horse. 8". $15-20.

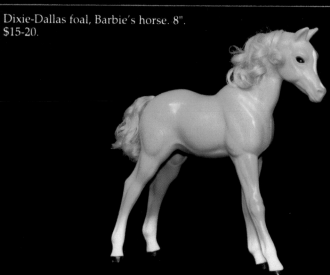

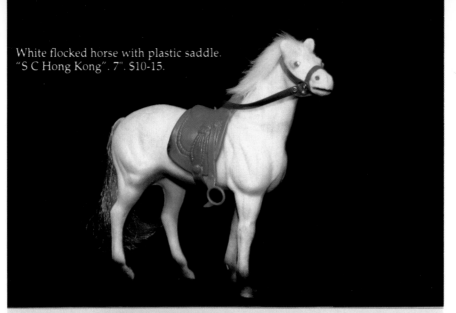

White flocked horse with plastic saddle. "S C Hong Kong". 7". $10-15.

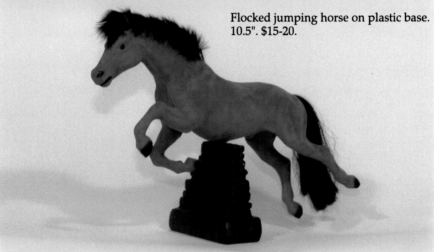

Flocked jumping horse on plastic base. 10.5". $15-20.

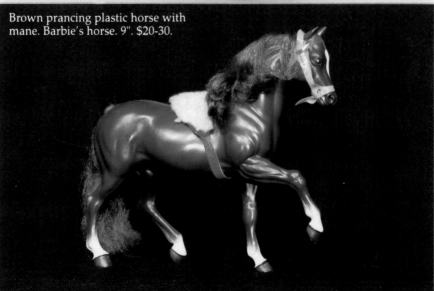

Brown prancing plastic horse with mane. Barbie's horse. 9". $20-30.

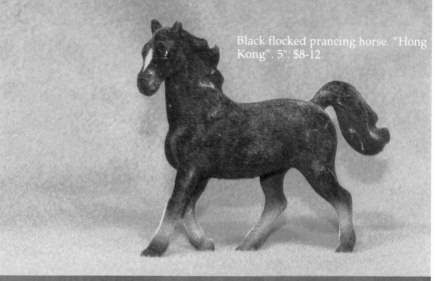

Black flocked prancing horse. "Hong Kong". 5". $8-12.

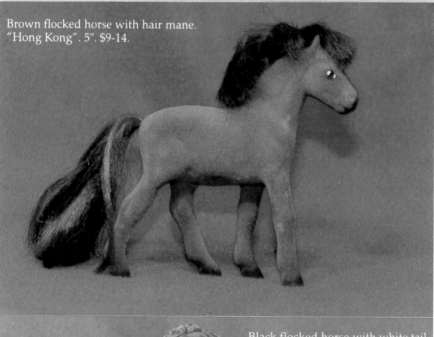

Brown flocked horse with hair mane. "Hong Kong". 5". $9-14.

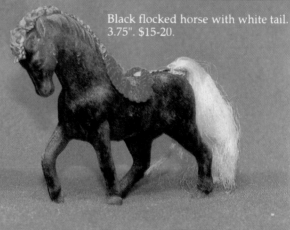

Black flocked horse with white tail. 3.75". $15-20.

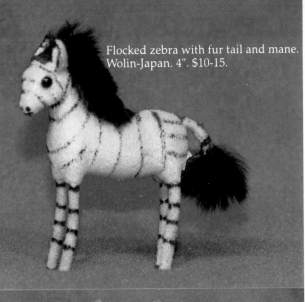

Flocked zebra with fur tail and mane.
Wolin-Japan. 4". $10-15.

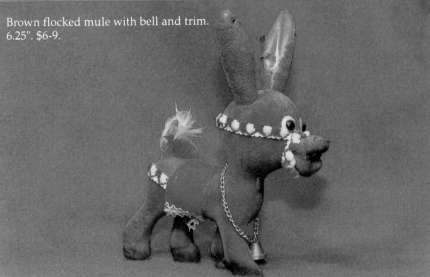

Brown flocked mule with bell and trim.
6.25". $6-9.

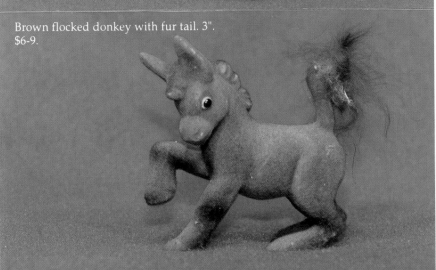

Brown flocked donkey with fur tail. 3".
$6-9.

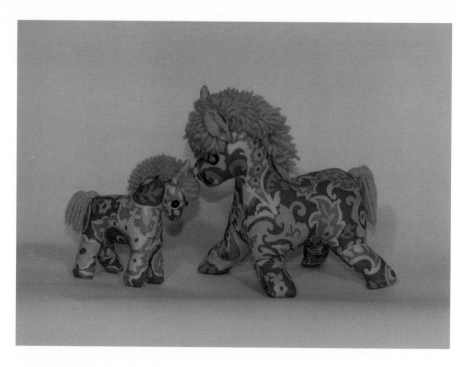

Mod cotton fabric, plush ponies. Yarn mane and tail. 10" and 6.5". $12-15.

Red plush horse, Fun Farm. 1979. 7". $3-6.

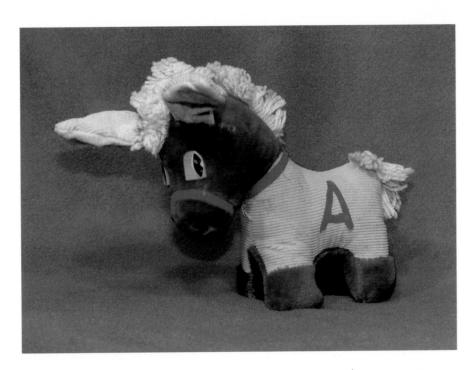

Plush donkey with sweater and yarn mane and tail. Holiday Fair. 1964. 7". $5-8.

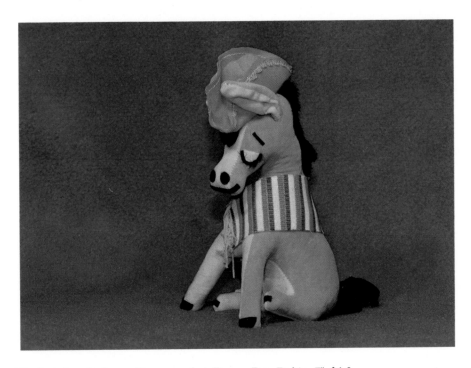

Plush sitting donkey with orange hat. Dream Pets-Dakin. 7". $6-9.

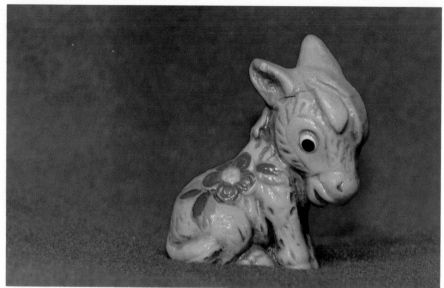

Yellow papier mache floral donkey.
1960s. 3". $5-8.

Real fur brown mule. 2". $6-10.

Pottery standing abstract horse. 4". $8-
12.

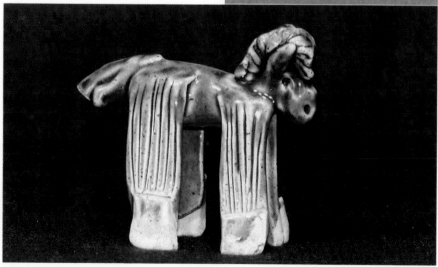

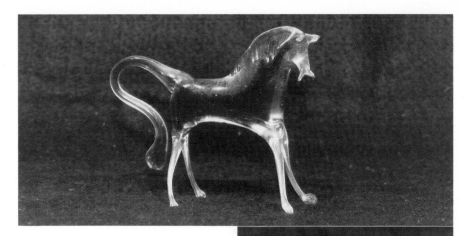

Blue Murano cobalt glass pony. 4". $35-45.

Blue blown glass prancing horse with jewel eye. 2". $12-16.

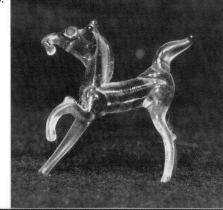

Pegasus blown glass figurine. 3.5" $16-20.

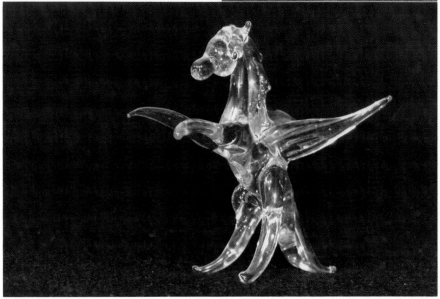

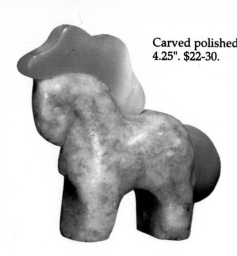

Carved polished stone standing horse. 4.25". $22-30.

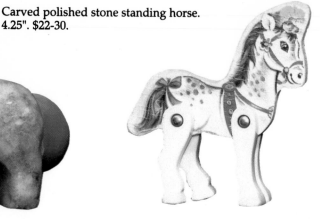

Wooden and plastic circus pony. 4". $6-8.

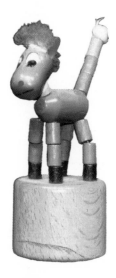

Wooden push puppet pony with strings that make the legs move. 2.5". $8-14.

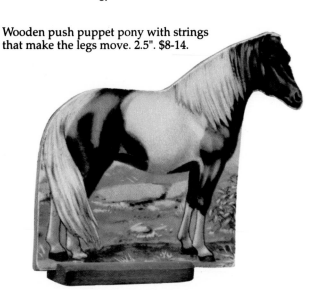

Cardboard shetland pony on stand. Front and back. 5" $8-12.

American Indian fetish, turquoise. 1". $18-22.

SHETLAND PONY

Possibly the smallest race of ponies is the Shetland, whose original home, as far as is known, was in the Shetland Islands, north of the British Isles. In general it is very hardy and possesses great strength in proportion to its size. The average height of the Shetland is about 42 inches, and it ranges in weight from 325 to 375 pounds. A good Shetland has a compact body, heavy muscular quarters, short legs; short, broad back; deep, full chest; thick, muscular neck; small head and ears, and prominent eyes. The coat should be long and shaggy, with a heavy, long mane and tail.

The Shetland's docile disposition and inclination to respond warmly to kindness makes it an ideal pet for children. Shetlands learn rapidly and withstand many hardships.

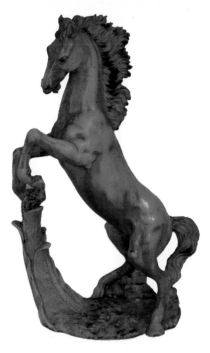

Molded resin rearing horse. 15". $45-55.

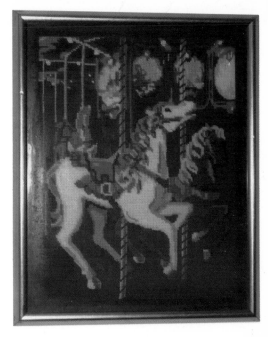

Needlepoint carousel horse. 12" x 16. $65-75.

Chalk triple horse with horse shoe, wall hanger. 7". 1960s. $25-35.

Old papier mache pony on wood stand. 21". $150-200.

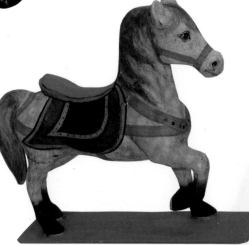

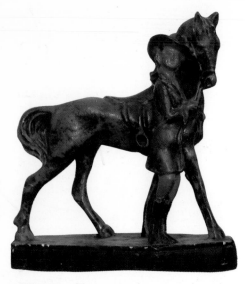

Chalkware horse and rider
No marks. 10". $25-35.

Chalk carnival horse on base. 11". $45-65.

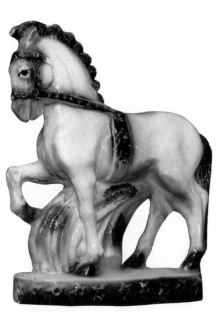

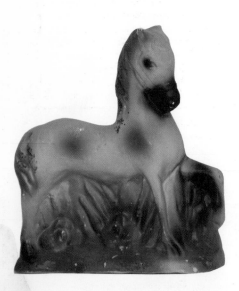

Chalk with glitter carnival horse. 6.5".
$20-25.